new views

International garden and plant photography

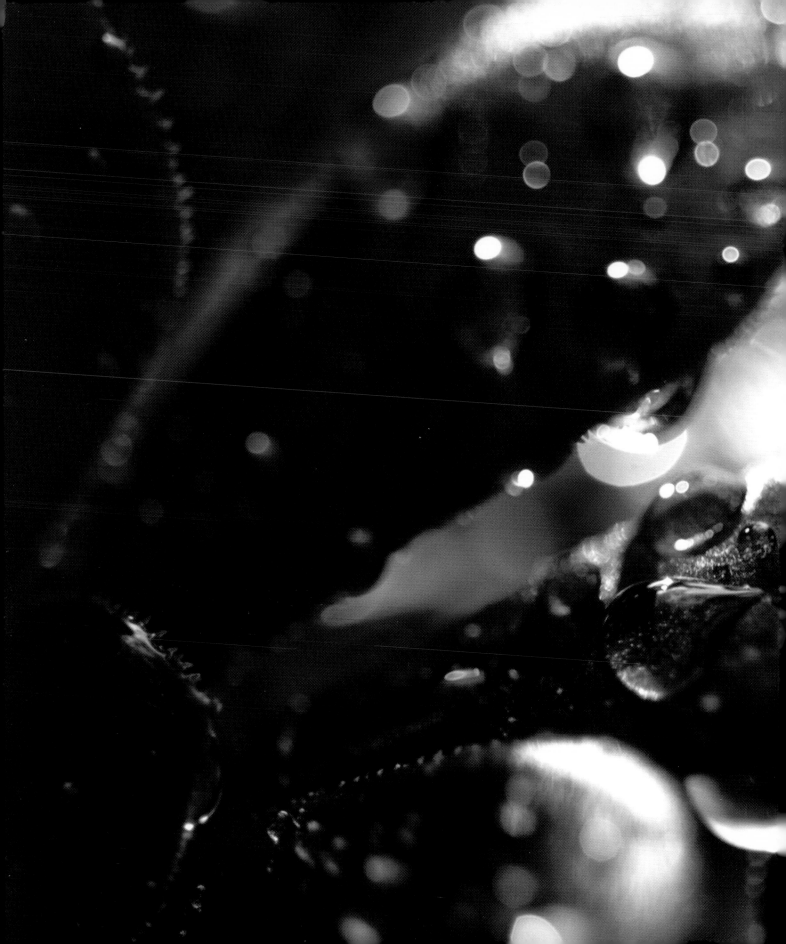

new views

International garden and plant photography

Kew
PLANTS PEOPLE
POSSIBILITIES

Garden Writers Guild

THIRD MILLENNIUM III
PUBLISHING, LONDON

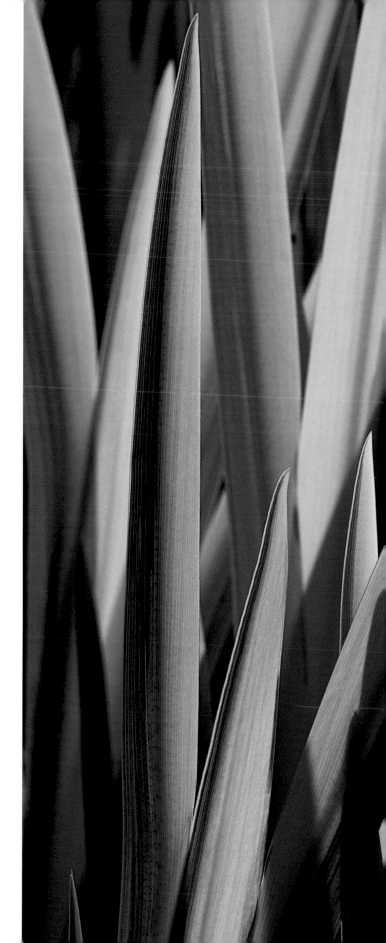

New Views

First published 2004 by Third Millennium Publishing Ltd,
a subsidiary of Third Millennium Information Ltd

Farringdon House
105–107 Farringdon Road
London
EC1R 3BU
www.tmiltd.com

Garden Photographers' Exhibition 2004 – *New Views*
Organisers: Helen Fickling, Jackie Hobbs, Gary Rogers,
Henrietta Van den Bergh

Designed and produced by Third Millennium Publishing
Printed and bound in Malta by Gutenberg Press Ltd

ISBN: 1 903942 36 5

Front cover:
Newly Formed *Nigella* Seedhead, Carol Sharp

Back cover:
TL: Pedunculate Oak, Andrew Lawson
TR: High Summer View, Gary Rogers
BR: Kew Montage 2, Paul Debois
BL: *Angelica* Unfurling, Anne Green-Armytage

Imprint page:
Iris pseudacorus 'Variegata', Jonathan Buckley

Frontispiece:
Raindrops on *Aeonium*, Tara Lee

contents

Foreword 6

Professor Sir Peter R. Crane FRS,
Director, Royal Botanic Gardens, Kew

Acknowledgements 8

Introduction 9

Henrietta Van den Bergh and Helen Fickling

A History of Garden Photography In Britain 12

Clare Foster

FINALISTS – NEW VIEWS 16

Index of Photographers 126

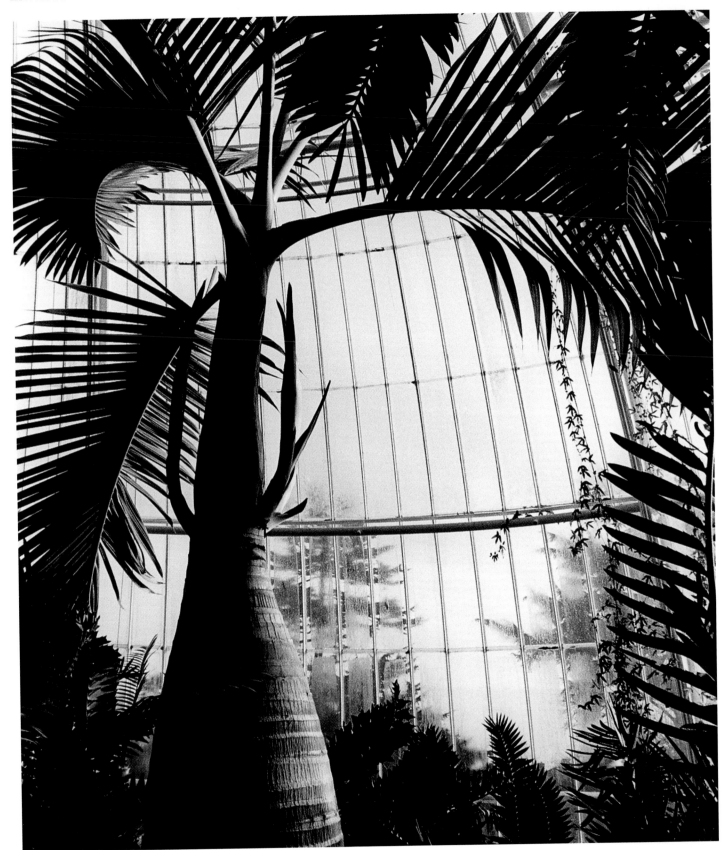

Inside Out, **Peter Baistow**

foreword

Every great garden, and especially a garden or landscape on the scale of Kew, is a living work of art that grows and develops through time, and changes with the seasons. Gardens, by their very nature, offer an active rather than a passive experience. Full enjoyment requires us not only to look, but also to engage and participate. Gardens draw us in with the promise of new experiences for our senses, each conjured up by the kinds of plants used, and how they are arranged. Combined with the subtleties of light, the state of the season, and many other factors, gardens deliver an endless flow of new perspectives, each with its own identity and potential.

The opportunities for capturing the essence of gardens in two dimensions are therefore endless. And whether through paint or photography, the result depends on exactly how the artist seeks to capture the beauty of a special, and often fleeting, moment. This remarkable book provides 100 stunning images of such moments seen through the lenses of some of the most talented garden photographers anywhere in the world. These images reflect a range of individual experiences, and capture the distinctive beauty of a vast range of plants, gardens and landscapes. Many of the images feature specific plants and perspectives from Kew. Some of these are familiar sights, such as the Palm House, but are shown in a new light.

Still others find their magic in the elegance of plants viewed in particular ways or from particular angles. The images illustrate the sheer beauty and variety of Kew. I hope that they also enhance the pleasure that you take from the plants and places of Kew and other gardens.

On behalf of all staff of The Royal Botanic Gardens, Kew, I want to congratulate the many skilled photographers who have contributed to the marvellous collection of photographs in this exhibition. I also want to express our thanks to Henrietta Van den Bergh, Helen Fickling and their team, who have assembled this magnificent book. It was a great pleasure to host the **Garden Photographers' Exhibition 2004 – New Views** at Kew. Its diverse images help connect us with gardens and plants in new ways. I hope that you, along with the hundreds of thousands of visitors who viewed the exhibit during its time at Kew, enjoy these *New Views*.

Professor Sir Peter R. Crane FRS
Director
Royal Botanic Gardens, Kew

acknowledgements

The Garden Writers' Guild and the Garden Photographers' Group wish to express their sincerest gratitude to the many individuals who have given their time, expertise and help in making the exhibition and this publication possible, with special thanks to Third Millennium Publishing for producing this publication.

We also extend our grateful thanks to the Royal Botanic Gardens, Kew, for their unfailing enthusiasm and support, and to our judges who selected the images for this exhibition.

Special thanks also to the sponsors of the exhibition for their valued support.

introduction

Henrietta Van den Bergh and Helen Fickling

A visual feast of flowers, buds, seeds, petals, leaves, grasses, trees and landscapes come together in this collection of 100 exceptional images from some of the world's most talented photographers. The images are from the **Garden Photographers' Exhibition 2004 – *New Views***, organised by the Garden Photographers' Group. An independent panel of judges selected the work of over 50 photographers from more than 750 entries to this year's competition. The exhibition is organised in association with the Royal Botanic Gardens, Kew.

In 2000, the Garden Photographers' Group joined the Garden Writers' Guild to provide a forum to address issues within the horticultural community and to stimulate creativity amongst its members and associated professionals. The group has an active international membership of more than 120 photographers, many of whom are major contributors to horticultural media worldwide.

The Guild was established in 1991 as the national organisation of professional communicators associated with the horticultural community. Membership includes writers, broadcasters, photographers, artists and illustrators, along with book, magazine and newspaper publishers.

Theme and Categories

The theme – *New Views* – for this year's exhibition has three categories and takes inspiration from the title of Kew's 2004 Summer Festival, *New Views of Kew*.

'**New**' expresses the concept of 'newness' with images depicting new growth, buds, day, season… Traditional, digital and abstract approaches were used to explore new techniques to stretch the boundaries of photography in innovative and creative ways. Subjects could be chosen from anywhere in the world.

'**Views**' encompasses a broad range of treatments, from vast panoramic garden landscapes to macro studies of botanical interest, from the ultimate classic vistas to the unusual, offbeat vision of a garden, plant or detail – again, shot anywhere in the world.

'**Kew**' focuses on elements and aspects of the Royal Botanic Gardens, both at Kew and at Wakehurst Place, with an emphasis on unexpected angles and viewpoints.

Entries and Judging

Entries were received from as far afield as Australia, Italy, Japan, South Africa, Spain, and USA, with the majority from the UK. Interest was particularly welcomed from photographers outside the Garden Photographers' Group, who heard of the competition through various photographic magazines and associations, the exhibition website and other websites, and by word of mouth.

Judging took place at the Royal Botanic Gardens, Kew, on Tuesday, 9 March, with five judges taking on the challenging

task of selecting entries for inclusion in the exhibition. Each image was given a unique code to ensure it was judged purely on its technical and artistic merit, taking into account the category criteria. The standard was particularly high, making the judges' task an extremely difficult one.

Judges
Jess Walton – Creative Visual Research, London, UK
Jess Walton is a freelance picture editor and researcher, commissioning some of the world's leading photographers in interiors, lifestyle, landscape design, architecture, art and crafts.

Sian Lewis – Art Editor, Gardens Illustrated Magazine, London, UK
Gardens Illustrated is Britain's most authoritative gardening magazine for plants, people and places. Sian is one of the UK's top art editors, commissioning and buying photographs internationally, as well as designing and art directing this award-winning publication.

Chris Young – Editor, Garden Design Journal, UK
Garden Design Journal is the official magazine of the Society of Garden Designers. In 2003 Chris won the prestigious Garden Writers' Guild Award for Trade Journalist of the Year. He is closely involved in the International Festival of Gardens, Canada, and has been on the selection panel for Westonbirt Festival of Gardens, Gloucestershire, since its inception in 2000.

Laura Giuffrida – Exhibition and Live Interpretations Manager, Royal Botanic Gardens, Kew, Surrey, UK
Laura works closely with artists and professional photographers on Kew's ongoing exhibitions programme every year including those at White Peaks, an exhibition space at Kew recognised as a leading art and photography venue, as well as those at Wakehurst Place, Sussex.

Cleve West – Garden Designer, London, UK
Based in southwest London, Cleve has been designing gardens since 1990 and has several Royal Horticultural Society (RHS) awards for show gardens at the Hampton Court and Chelsea Flower Shows. His projects are varied, dealing with gardens of all sizes both at home and overseas.

Awards and Prizes
The winners of *New Views* were announced and awards presented at the exhibition launch event on Thursday 27 May, at White Peaks exhibition space, Royal Botanic Gardens, Kew. Professor Sir Peter Crane FRS, Director, Royal Botanic Gardens, Kew opened the evening, and presenter Matthew Biggs hosted the presentation of the awards by the sponsors.

BEST OF SHOW: Jonathan Buckley, *Nectaroscordum siculum*, Beth Chatto Gardens, Essex, UK

New

Best of Category: Jonathan Buckley, *Nectaroscordum siculum*, Beth Chatto Gardens, Essex, UK
Joint Second: Nadia Mackenzie, *Aloe Flower Buds*, Royal Botanic Gardens, Kew, UK; Rob Whitworth, *Dahlia 'David Howard'*, RHS Garden Wisley, Surrey, UK
Third: Derek Lomas, Chrysanthemum, London Studio, UK

Views

Best of Category: Clive Nichols, The Hosta Walk, Lady Farm, Somerset, UK
Second: Mimi Winter, London Landscape: Allotments 6.30am, South London, UK
Joint Third: Helen Fickling, Polka Dot, Pretoria, South Africa; Andrew Lawson, Pedunculate Oak, Marsland, Devon, UK

Kew

Best of Category: Paul Debois, Kew Montage 2, Royal Botanic Gardens, Kew UK
Joint Second: Mike Curry, Kew Pagoda, Royal Botanic Gardens, Kew, UK; Victoria Upton, Illusion, Royal Botanic Gardens, Kew, UK
Third: Andrew Lawson, Palm House (Inside Outside), Royal Botanic Gardens, Kew, UK

Judges' Favourites
- Richard Freestone, Poppy, Derbyshire Garden, UK
- Peter Baistow, Inside Outside, Royal Botanic Gardens, Kew, UK
- Jonathan Buckley, *Nectaroscordum siculum*, Beth Chatto Gardens, Essex, UK
- Helen Fickling, Polka Dot, Pretoria, South Africa
- Jane Sebire, View into King's Oozy, Dereen Garden, Co Kerry, Ireland

By raising the profile of garden and plant photography, the Garden Photographers' Group aims to promote and create an awareness of the work of its members and professional photographers internationally, confirming this genre of photography as a true art form that continues to stretch technical and creative boundaries.

For more information on the exhibition, please visit:
www.garden-photographers.com/exhibition

or email the organisers:
Helen Fickling: exhibition@garden-photographers.com
Henrietta Van den Bergh: press@garden-photographers.com

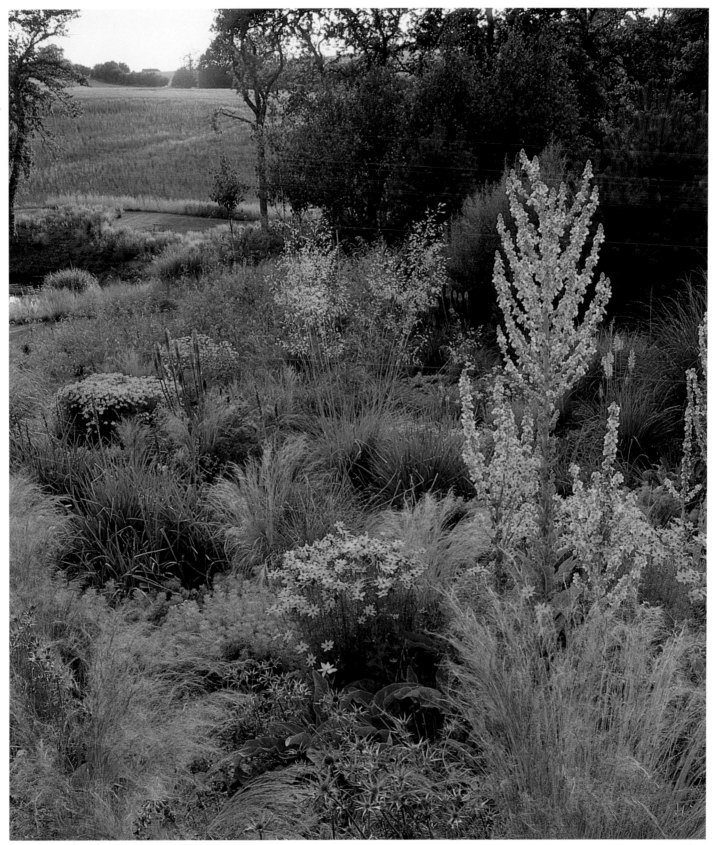

The Prairie at Lady Farm, **Marcus Harpur**

a history of garden photography in britain

Clare Foster, Editor, Gardens Illustrated

Gardens and photography have a natural, symbiotic relationship that has been evolving ever since the beginnings of photography in the early nineteenth century. The garden deserves to be recorded as a form of art in itself, and its ever-changing nature demands a medium that is quick, flexible and true. At its simplest, photography is a type of documentation, but it can also be seen as a form of art – and over the last century and a half we have seen garden photography move on from being merely a record to something that is much more thoughtful and imaginative, something that could certainly be called 'art'.

While the first experiments in garden photography were personal records (for example, those of William Henry Fox Talbot, the pioneer of photography, who took numerous pictures of the garden at his estate in Wiltshire), the work of these first photographers soon came to the attention of a wider audience through the printed media – and it is the nature of this relationship and its development over the last 150 years, that has enabled the profession of 'garden photographer' to flourish.

The story begins in 1841, when the first British horticultural magazine was launched by Edward Hudson, a friend of Gertrude Jekyll. Gardeners' Chronicle, edited in the early days by John Lindley, was a weekly publication for the gardener, with sections on Horticulture (including black and white photographs of individual gardens) and General News. Towards the end of the nineteenth century, in 1897, Country

Life was launched, and by this time the print industry had moved on, enabling better-quality reproduction in half-tone rather than line-engraving. From the start, the documentation of gardens with specially commissioned photography formed a core part of Country Life magazine, although the photographers themselves weren't always credited. One of them, Charles Latham, also an architectural photographer, provided most of the images for Volumes 2 and 3 of Country Life's first book venture, *Gardens Old and New: The Country House and its Garden Environment*, (3 vols), published 1900–08.

Although there were no dedicated garden photographers in the first half of the twentieth century, several gardeners and plantsmen developed an interest in photography that they were able to indulge alongside their day jobs. Probably the best known was Gertrude Jekyll, who, despite her poor eyesight, took photographs of her own garden, many of which appeared in her books. Charles Jones, who was Head Gardener at Ote Hall in Sussex at the end of the nineteenth century, took photographs for his own pleasure – his artistic arrangements of vegetables, somehow way beyond their time, were discovered by chance in an antiques market ten years ago. Others made a tidy living from photography, taking pictures for the proliferation of practical gardening books that appeared around the time of the Second World War. Ernest Crowson, J.E. Downward and Harry Smith were the three names of the 1940s and 1950s, working with Harold Hillier

a woman photographer appeared on the scene. Renowned plantswoman Valerie Finnis, encouraged by Downward, who gave her her first colour film, started taking photographs of plants and people in her spare time, building up a large archive containing portraits of some of the best-known names in the horticultural world.

As colour printing technology improved in the 1960s and 1970s, more garden magazines and books started to appear, but it wasn't until the 1980s and 1990s, that garden photography as a profession really took off. In the 1980s, gardening suddenly became the most popular British pastime, encouraged by characters such as the genial Geoff Hamilton, then presenter of the popular TV series Gardeners' World. People were thirsty for more knowledge, and the market for books – both practical and glossy – grew almost overnight, with high-quality publications appearing in droves from publishers such as Thames & Hudson and Frances Lincoln. Renowned plantsmen and women such as Christopher Lloyd and Rosemary Verey teamed up with photographers like Andrew Lawson to produce a number of timeless books that are still being reprinted today. In 1985, a milestone book was published. *Visions of Paradise*, with photographs by Marina Schinz, was a glossy hardback containing images of gardens all over the world – at last a book that portrayed the art of the garden, and it was the first of many to come.

From this point the role of the garden photographer really accelerated. The market was wide enough to accommodate those who wanted to make a living from photographing gardens and plants alone, and several pioneers led the way, all converging from different backgrounds. Andrew Lawson, today one of the best-known names in the business, came to photography from painting; Jerry Harpur from advertising photography. Clive Nichols was originally a travel and landscape photographer and Marianne Majerus specialised in architecture and portraiture. These, and many more, have felt an affinity with gardens and plants that has given them the desire to move away from other areas and specialise as garden photographers.

In the 1990s, the TV-watching public was initiated into the world of the garden makeover, which portrayed the garden as a kind of outdoor room, further galvanising people to get outside and into the garden. Referred to incessantly in the British press as the 'new rock 'n' roll', gardening could not have been more fashionable. People devoured information on gardening and garden-making, thus widening the market for books, magazines and the garden sections in daily or weekend newspapers. The last decade has seen unprecedented growth in the magazine market, with at least a dozen garden magazines launched between 1990 and 2004, including Gardeners' World, The English Garden, Gardens Monthly and most recently, Gardenlife.

Gardens Illustrated, launched in 1993, was the first magazine to focus on the visual qualities of the garden rather than the practical elements, crossing over into the closely

linked realms of art and architecture. Its launch marked the beginning of a new type of garden photography, and the magazine provided a showcase for more experimental and artistic work. Photographers such as David Loftus and Howard Sooley contributed a beguiling mixture of images, and became known for their trademark close-up studies of plants, experimenting with shallow-focus and black-and-white photographs. These were images that you would want to hang on your wall – beautiful and timeless, yet at times criticised by horticultural purists as too artistic to be informative.

So, what is the role of garden photography today and in the future, and does it have a place both in an editorial capacity and in fine art? Indeed, should the two be separated at all? The nature of many garden magazines and books, designed first and foremost to convey information to the reader, dictates that the photography must be reasonably 'straight'. The images are there to illustrate the horticultural text, and as such must work hard in order to earn their place on the page, conveying their visual message immediately and clearly.

But I also believe there is a niche in the printed media for the more artistic garden or plant image – after all, rules are meant to be broken, and boundaries can and should be blurred. People with an eye for design who appreciate and understand the art of garden-making (as opposed to the hard graft of gardening) will also appreciate the fact that gardens and plants can be portrayed in a sensitive, artistic way on the pages of a magazine or book. To them, a close-up, soft-focus photograph of a peony, for example, will make them dash out into their own garden to look at the plant in more detail rather than feel frustrated that the photograph is blurred. These people want visual excitement. So, hand-in-hand with advancing technology, garden photography should move on too, and those influential in the printed media should also be looking for ways to push boundaries, encouraging photographers to be innovative and exciting.

If this sense of momentum and experimentation is sustained, more garden photography will find its way into the realm of fine art, as demonstrated at this year's Garden Photographers' Exhibition at Kew. The breadth and diversity of the work shown were breathtaking. From Jonathan Buckley's ethereal close-up image of *Nectaroscordum siculum* about to burst forth from bud, to Paul Debois' fascinating montage of a scene at Kew, every imaginable aspect of the subject was examined, capturing the energy and excitement that seems to be the keynote in garden photography at the moment. Today there are over 80 professionals in this country alone who choose to specialise in garden photography. With the continuing buoyancy of the garden magazine market and the general level of interest in gardening – which, let's face it, is hardly going to die overnight – there must be room for all of them. Riding on the wave of all this creativity, how can the medium of garden photography fail to thrive?

When your mouth drops
open, click the shutter

HAROLD FEINSTEIN

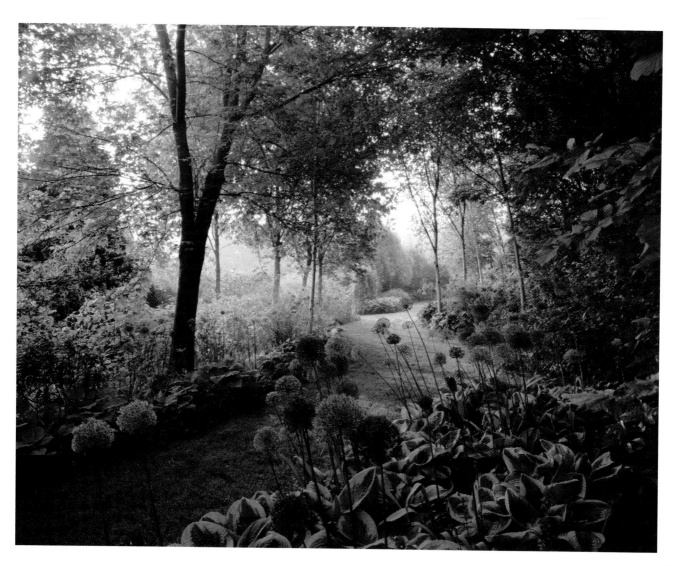

The Hosta Walk 1
Clive Nichols

Lady Farm, Somerset, UK
Colour transparency shot on Pentax 67

Category: Views

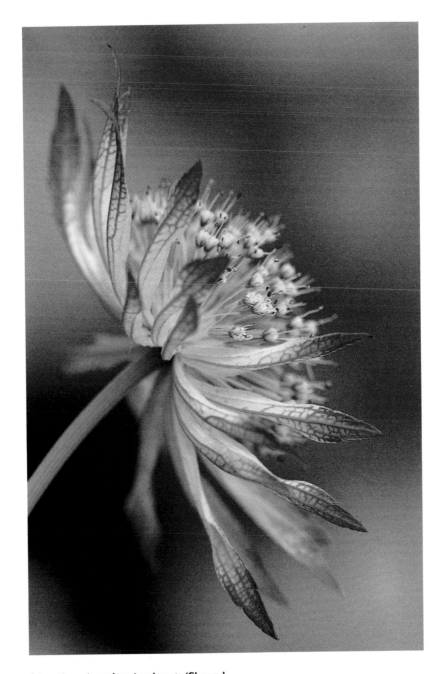

***Astrantia major* subsp. *involucrata* 'Shaggy'**
Jonathan Buckley

Mayroyd Mill House, Yorkshire, UK
Colour transparency shot on Nikon F100

Category: Views

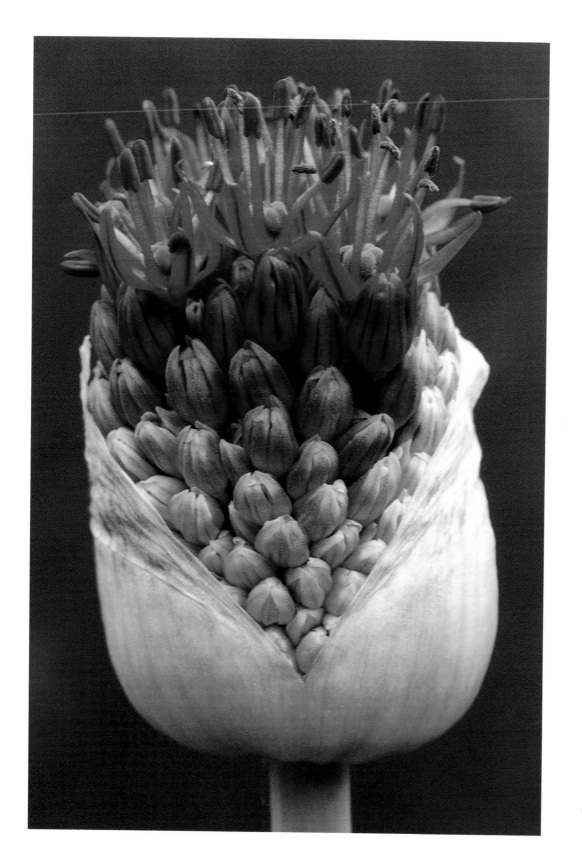

Emerging *Allium*
Andy Small

Hampshire, UK
Colour transparency
shot on Contax RTS3

Category: New

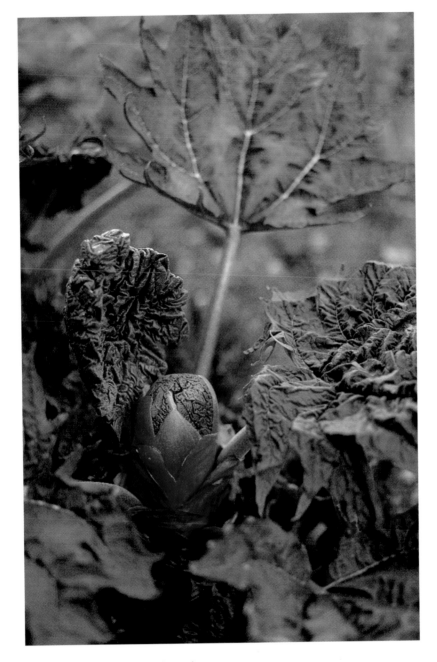

***Rheum palmatum* 'Atrosanguineum'**
Caroline Hughes

The Meadows Nursery, Mells, UK
Colour transparency shot on Nikon Fe

Category: New

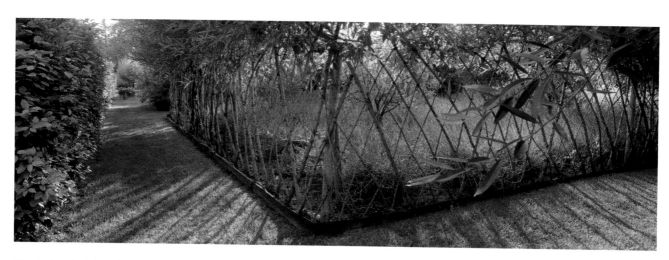

The Alchemist's Garden
Andrea Jones

Le Jardin de L'Alchimiste, Mas de la Brune
Eygalieres-en-Provence, France
Colour transparency shot on Fuji GX 617

Category: Views

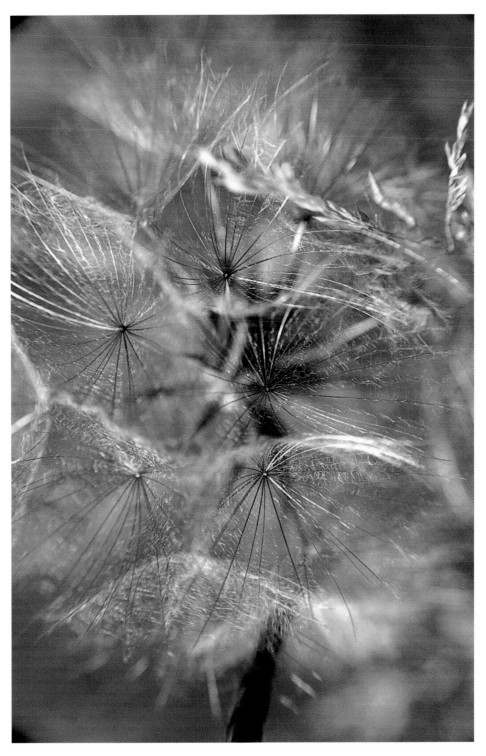

New Life
Estelle Cuthbert

Wiltshire, UK
Colour transparency
shot on Nikon F80

Category: New

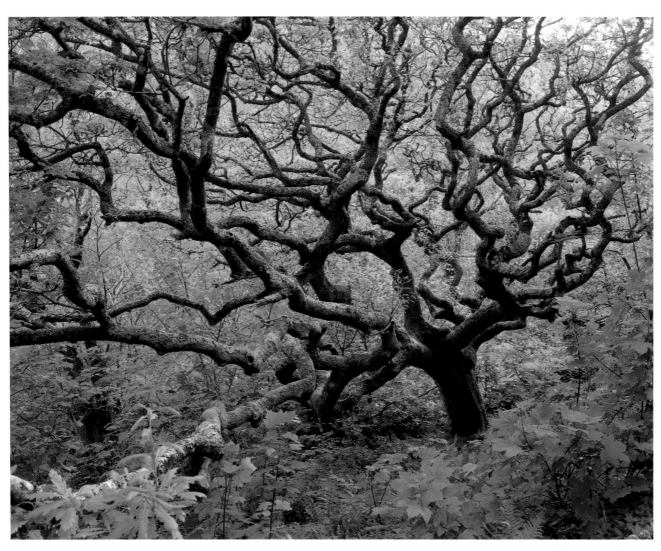

Pedunculate Oak 3
Andrew Lawson

Marsland, Devon, UK
Colour transparency shot on Pentax 6x7

Category: Views

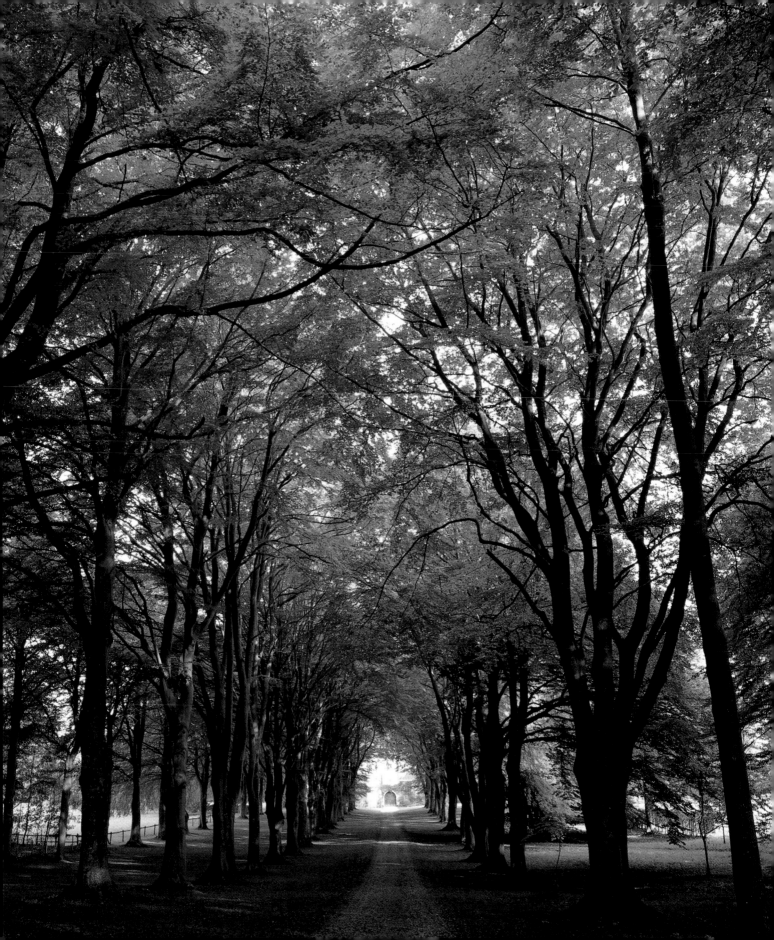

**Beech Avenue at Cranborne
Manor**
Mark Bolton

Cranborne Manor, Dorset, UK
Colour transparency shot on 6x7

Category: Views

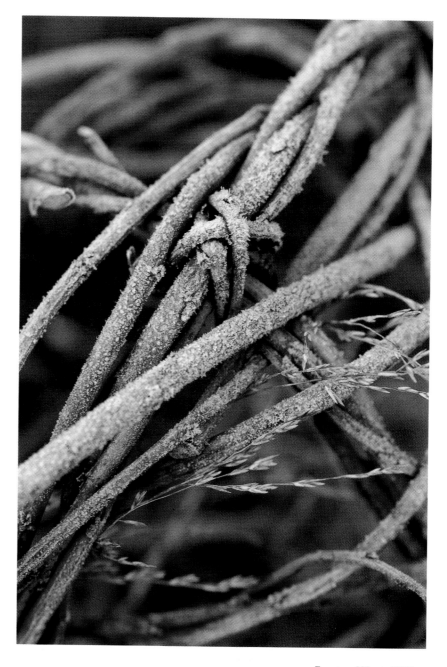

Frost on Woven Willow
Jo Whitworth

I Test Cottages, Hampshire, UK
Colour transparency shot on Nikon F100

Category: New

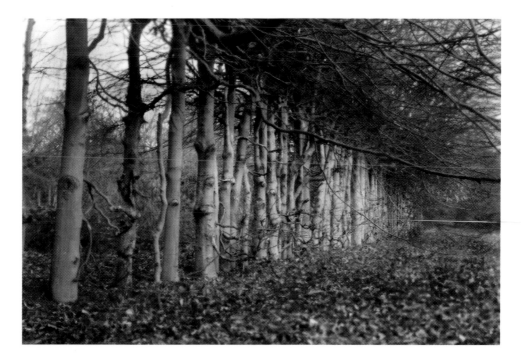

Beech Trees
Paul Debois

Parkland, London. UK
Digital shot on a Canon 10D, digitally enhanced

Category: Views

The Prairie at Lady Farm
Marcus Harpur

Lady Farm, Chelwood, Somerset, UK
Colour transparency shot on Nikon F100

Category: Views

Arley Arboretum
Clive Nichols

Worcestershire, UK
Colour transparency shot on Pentax 67

Category: Views

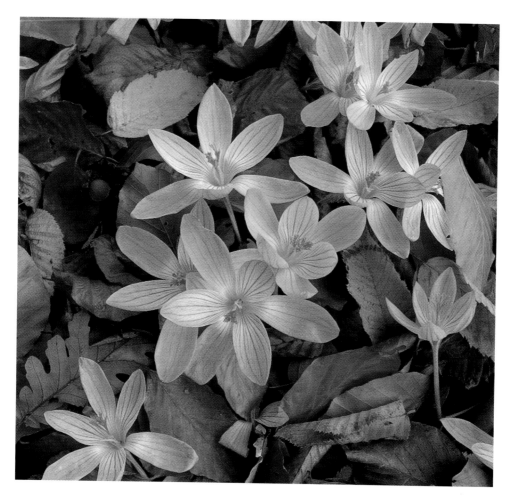

Blooming Autumn
Helen Fickling

Royal Botanic Gardens, Kew, UK
Colour transparency, shot on Nikon F3

Category: Kew

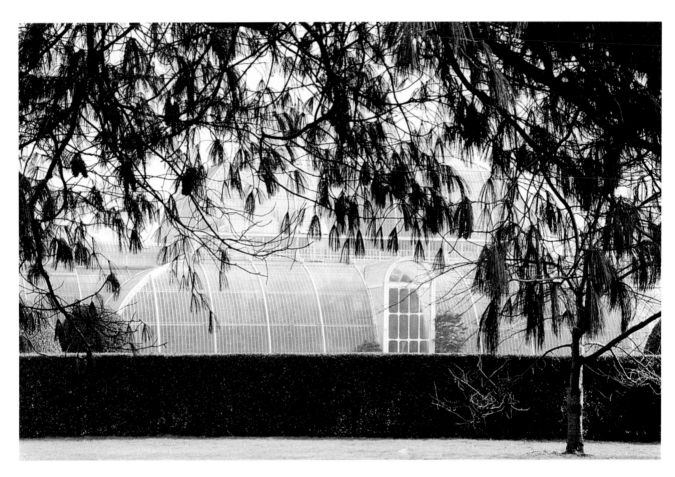

The Palm House
Liz Eddison

Royal Botanic Gardens, Kew, UK
Black and white negative film, shot on Nikon FM3A

Category: Kew

***Narcissus* 'Spellbinder'**
Trevor Nicholson Christie

Harlow Carr, Harrogate, UK
Colour transparency shot on Contax RTSIII

Category: New

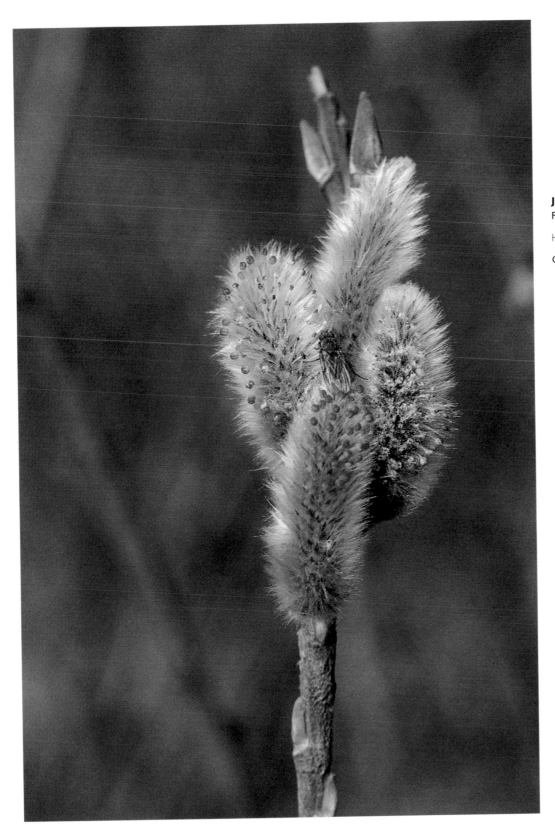

Japanese Pussy Willow
Francoise Davis

Hyde Hall, Essex, UK

Category: New

Emerging Bud, Leaves of *Sambucus racemosa* **'Plumosa Aurea'**
Clive Nichols

Oxford Botanic Garden, Oxford, UK
Colour transparency shot on Nikon F90X

Category: New

Breckland Sunrise
Anne Green-Armytage

Private Garden, Norfolk, UK
Colour transparency shot on Hasselblad 501CM

Category: Views

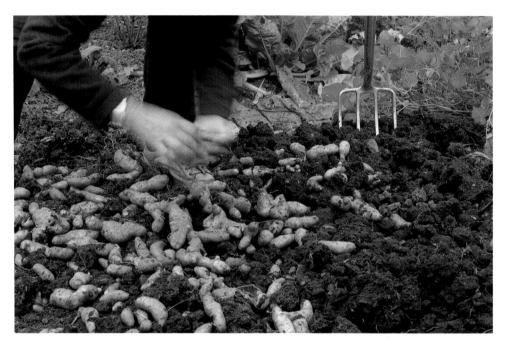

'Pink Fir Apple' Potatoes
Trevor Nicholson Christie

Own Garden, UK
Colour transparency shot on Contax RTSIII

Category: New

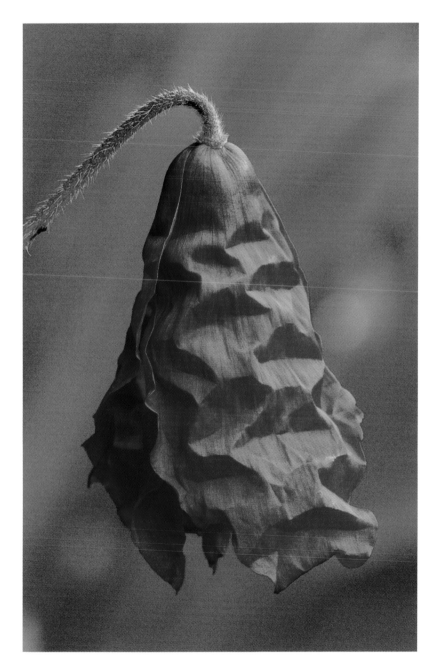

Meconopsis punicea
Jonathan Buckley

Upper Mill Cottage, Kent, UK
Colour transparency shot on Nikon F100

Category: New

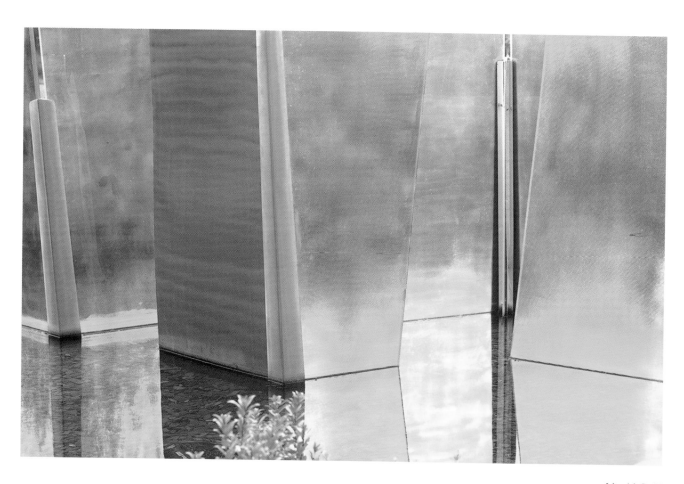

Liquid Gold
Helen Fickling

Westonbirt Festival of Garden, UK
Colour transparency shot on Mamiya RZ67

Category: New

Wires for Wall-Climbers
Andrew Lawson

Oxford, UK
Colour transparency shot on Canon F1

Category: New

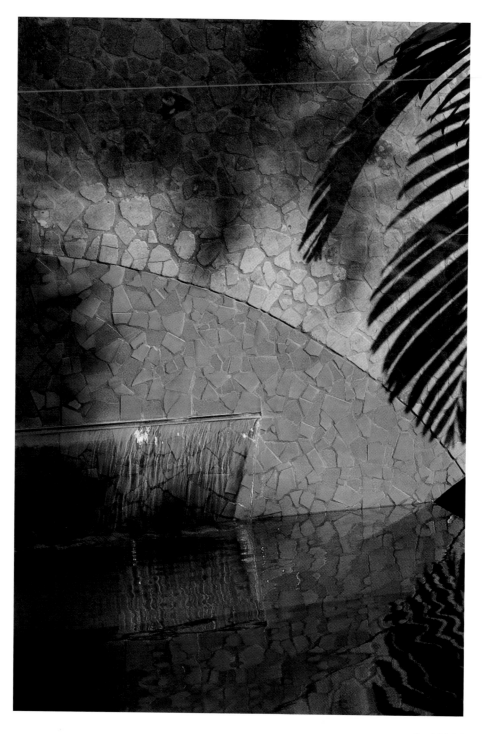

Last Light
Helen Fickling

Private garden, Bone Island, Florida, USA
Colour transparency shot on Hasselblad 500CM

Category: Views

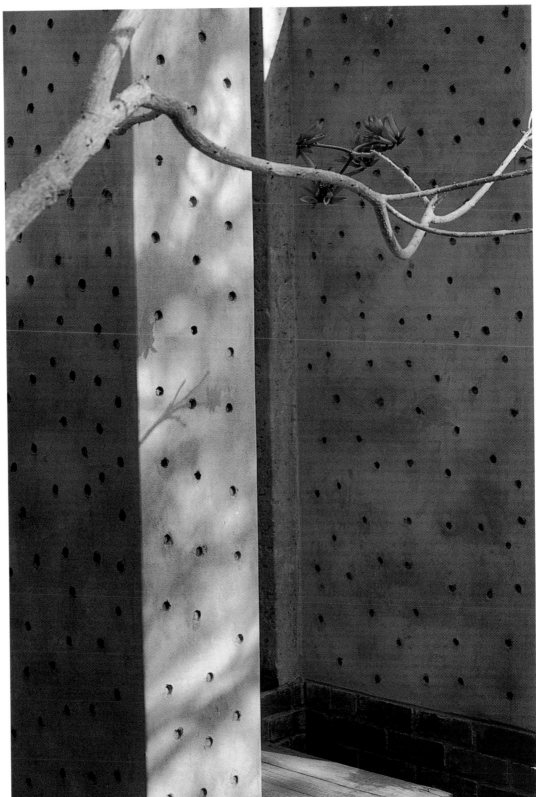

③ Polka Dot
Helen Fickling

Pretoria, South Africa
Colour transparency shot
on Nikon F3

Category: Views
Judge's Favourite

Cleve West
Garden Designer, London, UK

Choosing a favourite from over 750 photographs was to prove a daunting task but Helen Fickling's detail of a Coral Tree stood out from the start. Edible close-ups of flowers did their best to seduce, but this potentially desolate scene brought to life by light, shadow and a dash of vibrant colour, caught my imagination.

While this hardly qualifies as a landscape shot (of which there were few) the hard elements create a powerful and potentially difficult backdrop to work with. The captured light has given the surrounding walls a vibrancy suggesting that the natural pigment of the textured render is imbued with the flower's radiance. A potent evocation of life where you'd least expect it. Shadows add depth, and the composition, like the flowering nature of the plant, teases you to want to see more, even though you suspect it might let you down.

The final choices were not easy, and I must admit to an element of subjectivity. Contrast between the spartan setting and the intensity of the flower colour struck a chord with my own preference regarding the use of such colours in the context of a garden: understated textural contrasts with pin-points of colour accentuated by the surrounding restraint.

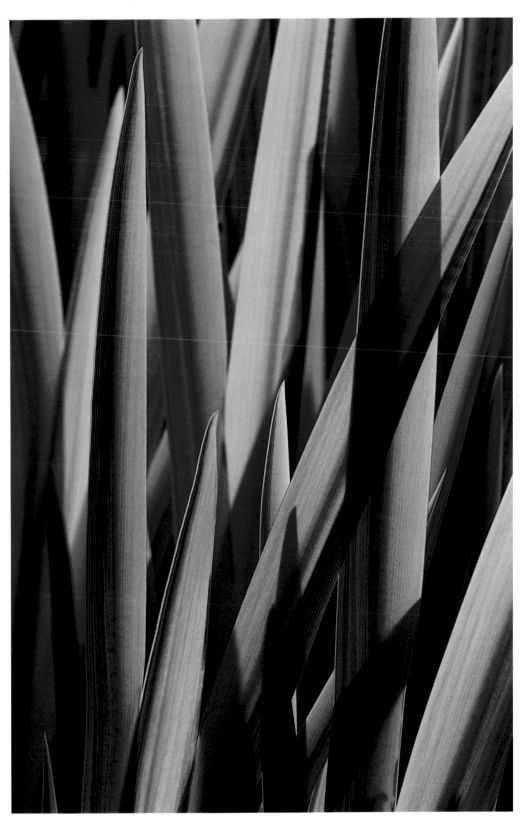

Iris pseudacorus **'Variegata'**
Jonathan Buckley

RHS Garden Wisley, UK
Colour transparency shot
on Nikon F100

Category: Views

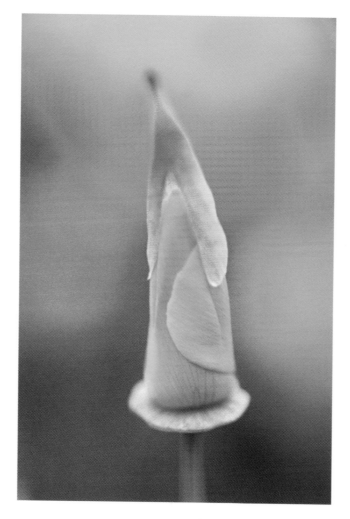

Californian Poppy Emerging
Carol Sharp

Norfolk, UK
Colour transparency shot on Nikon FM2

Category: New

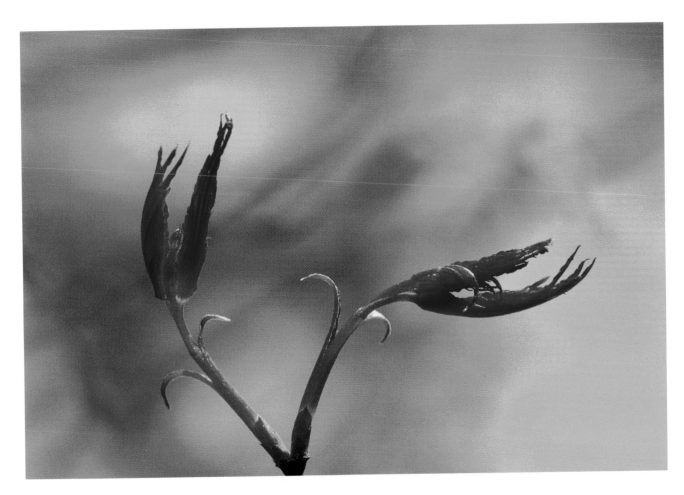

***Acer palmatum* 'Deshojo'**
Jonathan Buckley

Barleywood, Hampshire, UK
Colour transparency shot on Nikon F100

Category: New

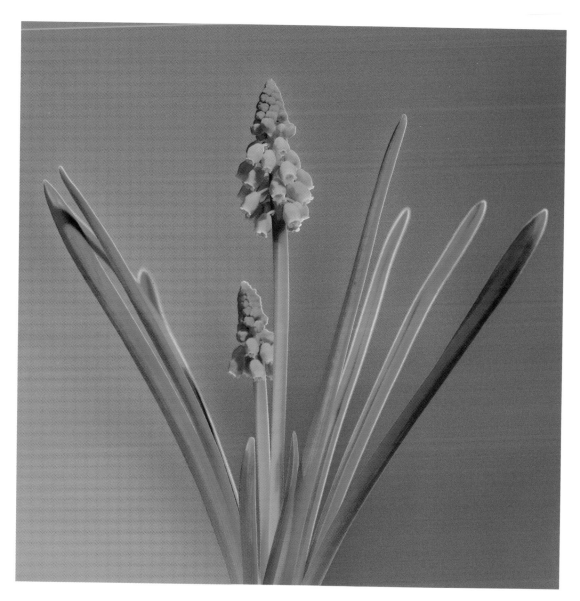

Grape Hyacinth – *Muscari armeniacum*
Johnny Greig

London Studio, UK
Colour transparency shot on Bronica SQAi

Category: New

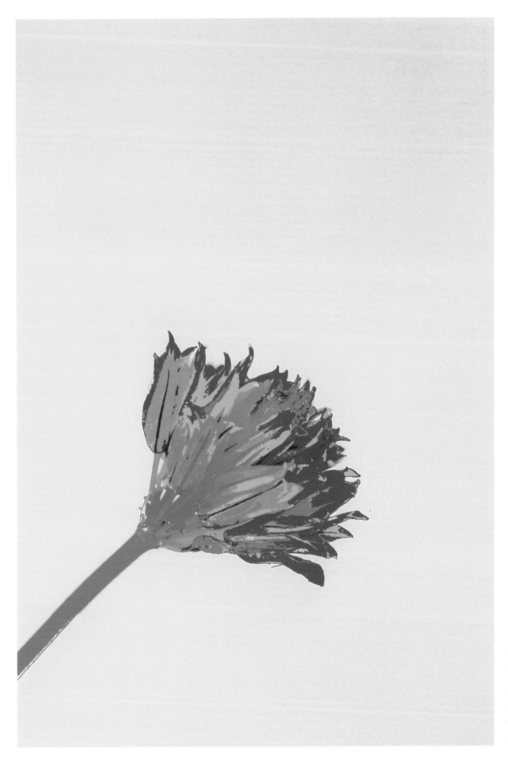

Chives Poster
Paul Debois

Studio/Garden, UK
Digital shot on Canon 10D,
digitally manipulated

Category: New

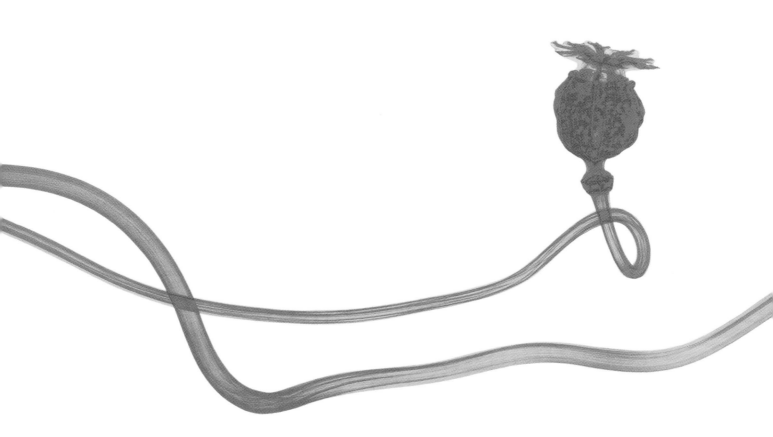

Seedpod
Isabelle Anderson

University Hospital of Wales
X-ray photograph, shot on colour transparency,
scanned and digitally enhanced

Category: New

Untitled
Victoria Upton

Royal Botanic Gardens, Kew, UK
Cross processed image

Category: New

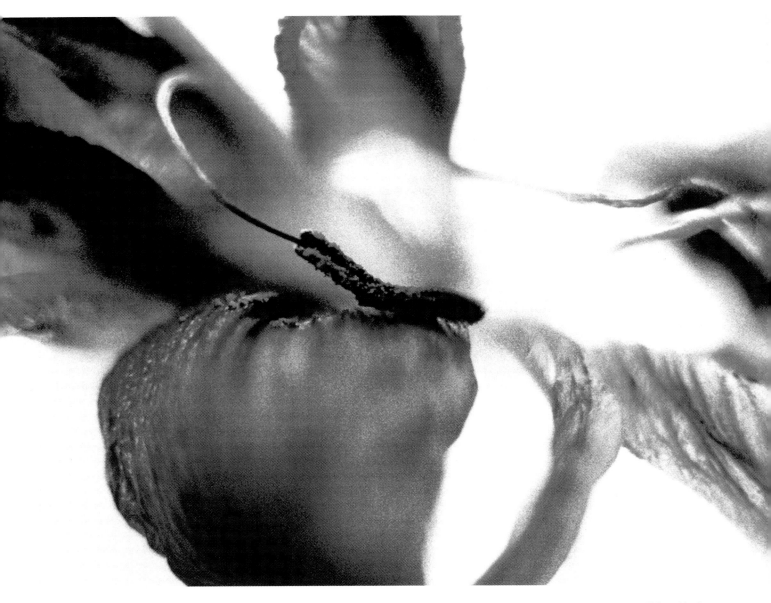

Edges No.6
Sanders Nicolson

Studio, London, UK
Colour negative shot on Nikon

Category: New

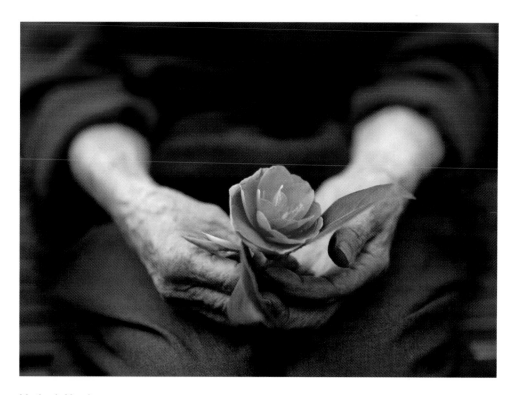

Mother's Hands
Mark Harwood

Own Garden, London, UK
Colour transparency shot on Nikon F100

Category: New

**Cold Winter Day at the
Alpine House**
Tomoko Suzuki

Royal Botanic Gardens, Kew, UK
Colour negative shot on Nikon F3

Category: Kew

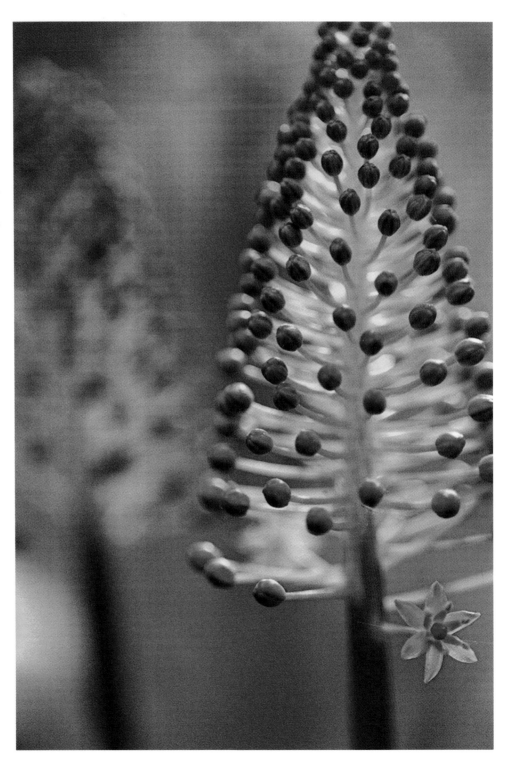

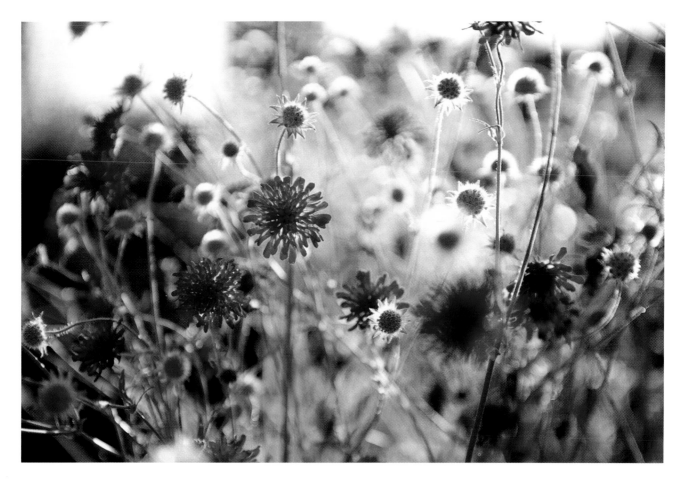

High Summer View
Gary Rogers

North England, UK
Colour transparency shot on Nikon F3

Category: Views

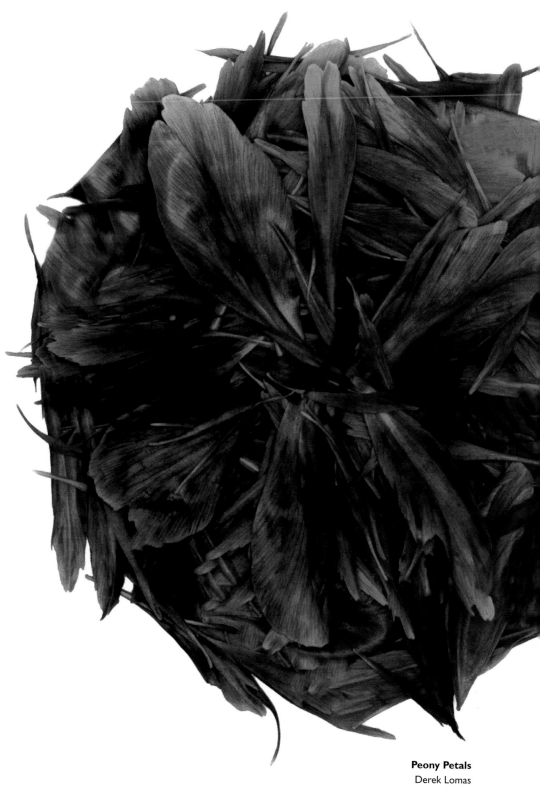

Peony Petals
Derek Lomas

London Studio, UK
Colour transparency shot on Sinar 5x4, digitally enhanced

Category: New

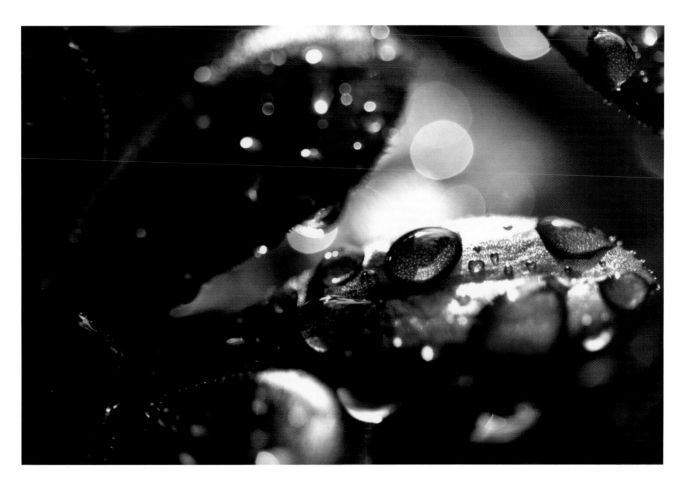

Raindrops on *Aeonium*
Tara Lee

RHS Chelsea Flower Show, London, UK
Colour transparency shot on Canon EOS 1V

Category: New

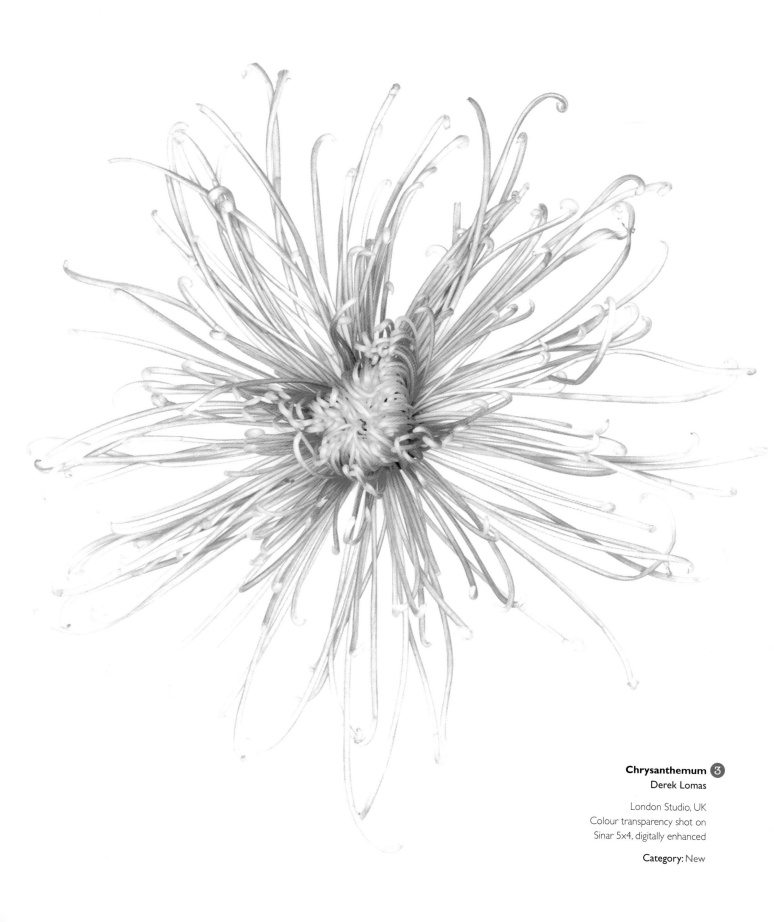

Chrysanthemum ❸
Derek Lomas

London Studio, UK
Colour transparency shot on
Sinar 5x4, digitally enhanced

Category: New

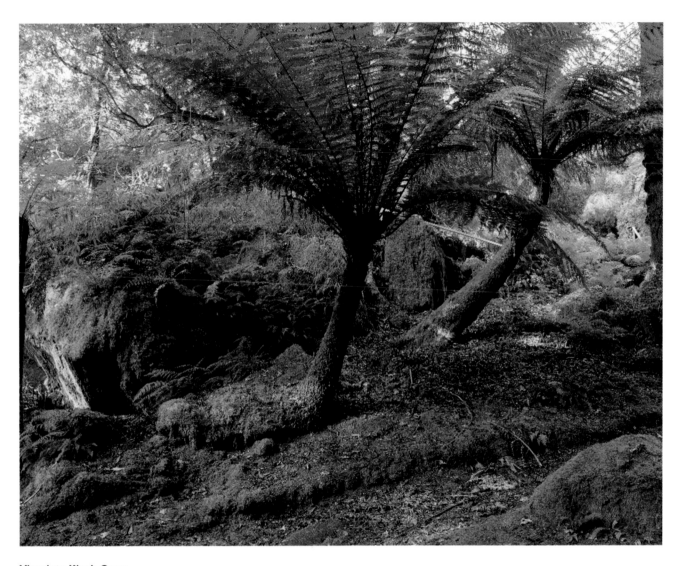

View into King's Oozy
Jane Sebire

Dereen Garden, Co. Kerry, Ireland
Colour transparency shot on Pentax 6x7II

Category: Views
Judge's Favourite

Judge's Favourite

Sian Lewis
Art Editor, Gardens Illustrated magazine, London, UK

This picture attracted me because of the moody atmosphere the shadows create, and the enormous tones of rich greens within a more or less single colour photograph.

It is not only a great shot of tree ferns, but also has a mysterious feel – as if you were wandering in the heart of an ancient wood, and looking up, can see a beautiful grid-like umbrella formed by the fronds of the ferns. There are a few patches of light to catch the eye as it takes in the vast range of greens, from the blue greens of the bracken, to the almost black greens of the tree trunks.

The photographer has paid special attention to composition. Although there are many elements to the picture, the trees sit comfortably slightly off-centre, though this does not look contrived.

It is a picture that looks good both from afar and close up.

A picture is the
expression of an
impression. If the
beautiful were not
in us, how would we
ever recognize it?

ERNST HAAS

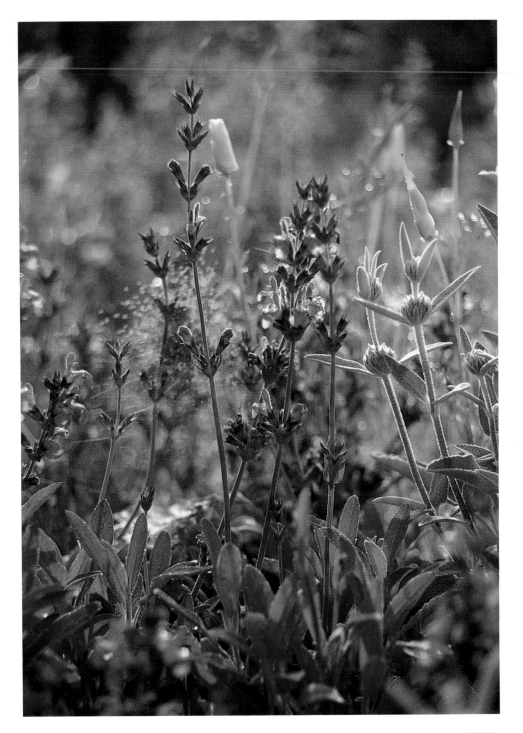

Melody
Michelle Garrett

Castle Farm, Kent, UK
Colour transparency shot on Nikon FM3

Category: Views

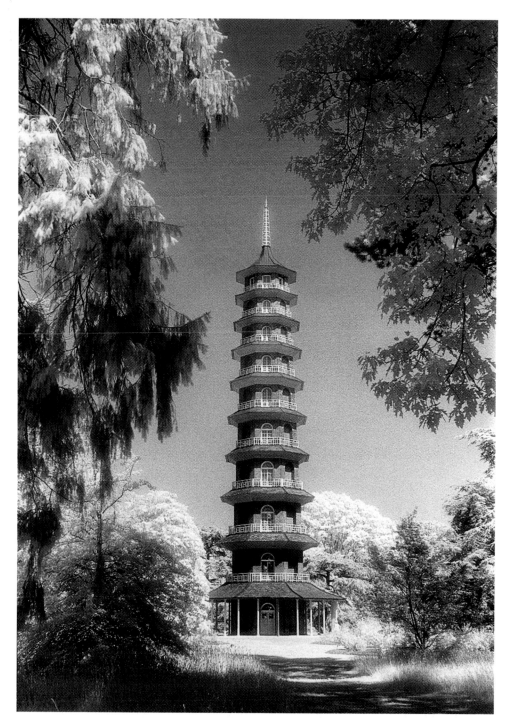

Kew Pagoda
Mike Curry

Royal Botanic Gardens, Kew, UK
Infra red film on Nikon F301

Category: Kew

Sea of Crocus
Andrea Jones

Royal Botanic Gardens, Kew, UK
Digital shot on Kodak Professional 14n digital camera

Category: Kew

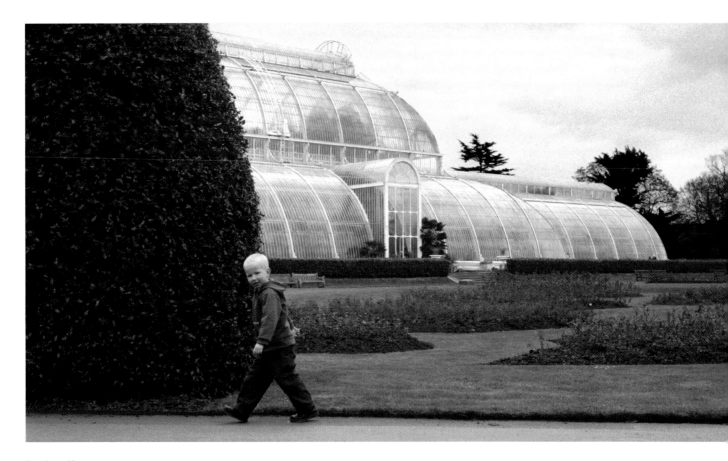

Jacob at Kew
Derek Lomas

Royal Botanic Gardens, Kew, UK
Colour transparency shot on Sinar 5x4

Category: Kew

***Geranium* 'Johnson's Blue' Montage**
Paul Debois

Studio/Garden, UK
Colour transparency shot on Canon EOS 1N, digitally manipulated

Category: New

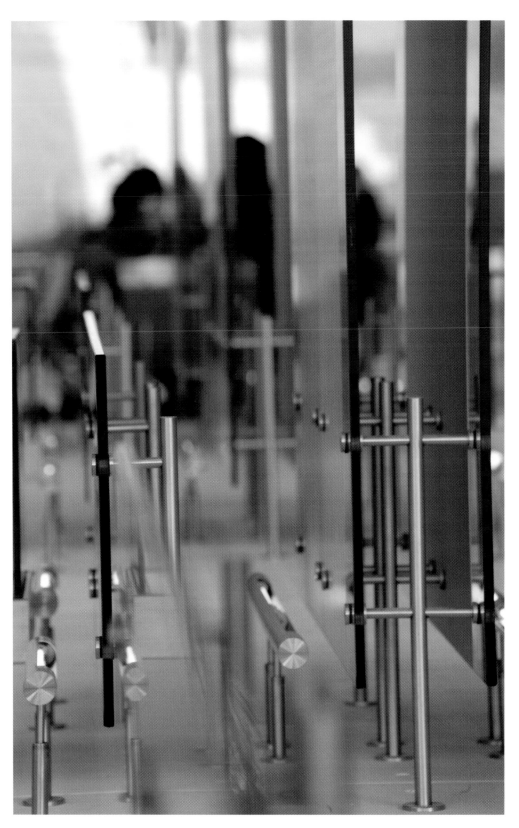

Millennium Seed Bank
Richard Loader

Royal Botanic Gardens, Kew, UK
Digital shot on Canon EOS IDS

Category: Kew

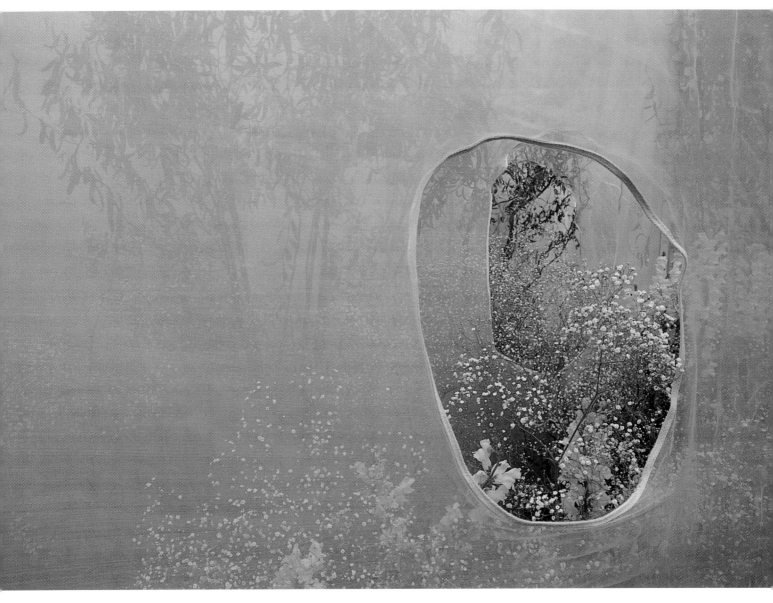

The Seventh Veil
Helen Fickling

Chaumont-sur-Loire, France
Colour transparency shot on Nikon F3

Category: New

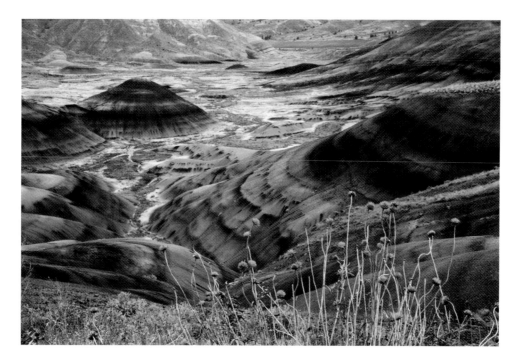

Painted Hills and Seedheads

Jo Crowther

Oregan, USA
Colour transparency shot on Nikon FE2

Category: Views

Macro Landscape
Estelle Cuthbert

Wakehurst Place, Sussex, UK
Nikon F80

Category: Views

Flower in Studio
Charlie Hopkinson

Peckham, London, UK
Colour transparency shot on 5x4

Category: Views

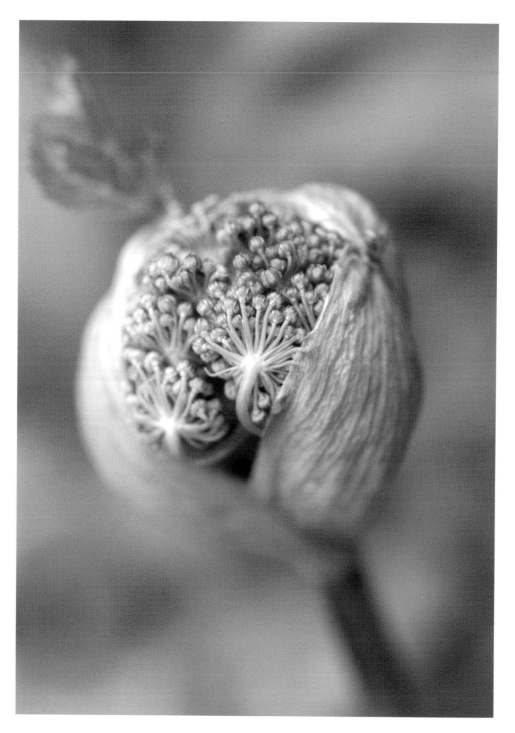

Anne Green-Armytage
Angelica Unfurling

Private Garden, Norfolk, UK
Colour transparency shot on Nikon 801s, digitally toned

Category: New

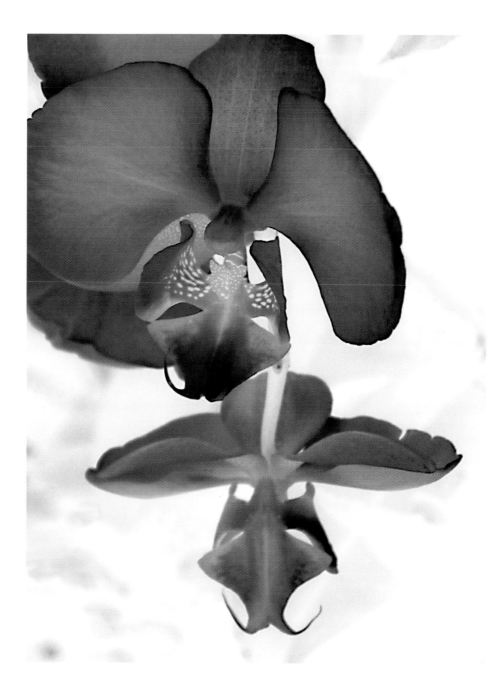

Orchid V
Nadia Mackenzie

Royal Botanic Gardens, Kew, UK

Category: Kew

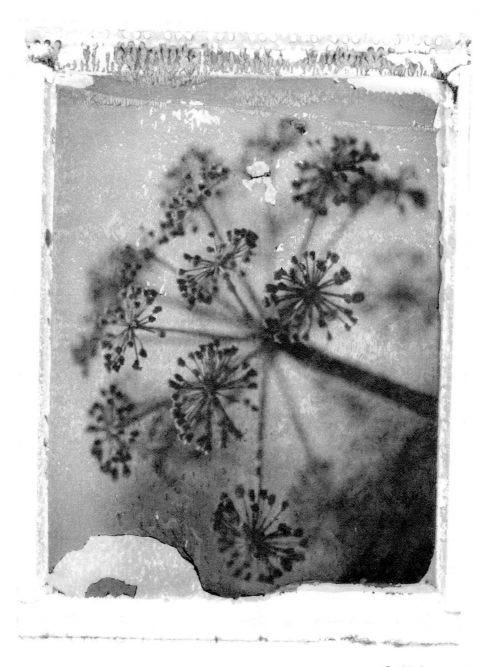

Gothic Summer II
Susan Bell

Westonbirt Festival of the Garden
Colour polaroid 5x4 emulsion transferred to fine art paper

Category: New

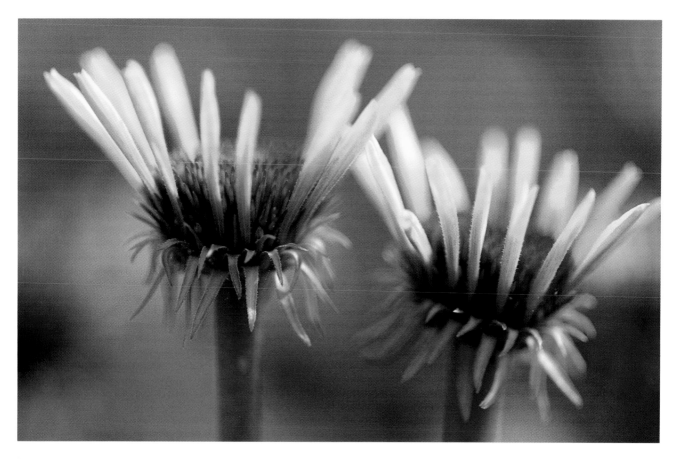

Echinacea Flowers Opening
Jo Whitworth

RHS Gardens, Wisley, Surrey, UK
Colour transparency shot on Nikon F100

Category: New

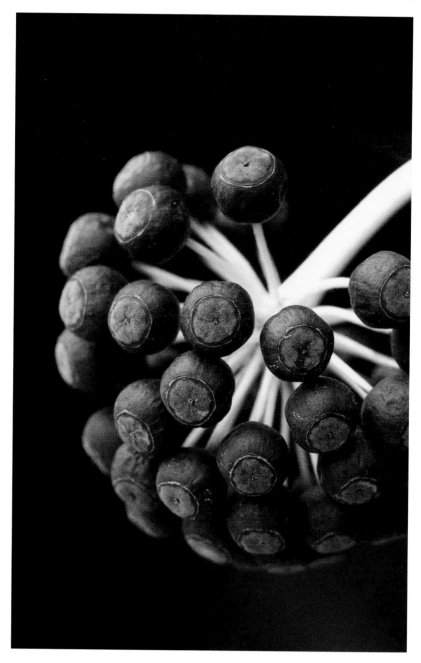

Fatsia japonica
Jonathan Buckley

Great Dixter, East Sussex, UK
Colour transparency shot on Nikon F100

Category: Views

Blue Savannah I
Rachel Fish

Studio, Sydney, Australia
Digital image shot on Mamiya 654 with Sinar digital back

Category: Views

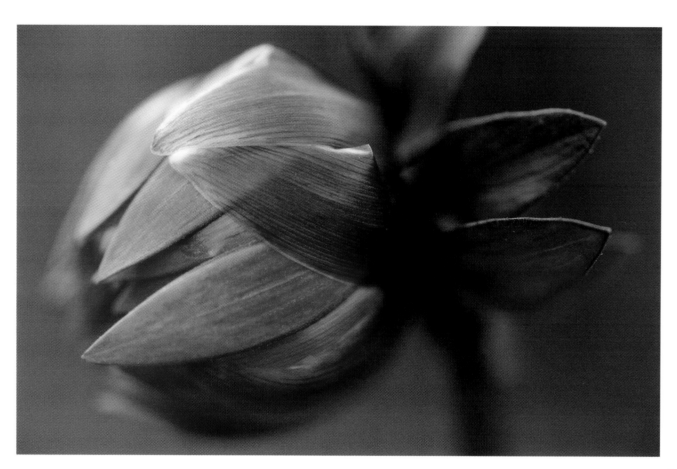

Dahlia 'David Howard' 2
Rob Whitworth

RHS Gardens, Wisley, Surrey, UK
Colour transparency shot on Nikon F100

Category: New

Fractal Fronds
Steve Gosling

Harlow Carr, Harrogate, UK
Colour transparency shot on Canon EOS 1N

Category: New

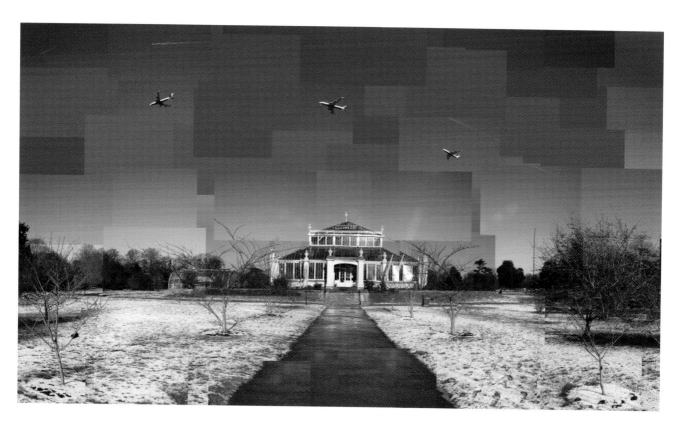

Kew Montage 2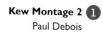
Paul Debois

Royal Botanic Gardens, Kew, UK
Montage of digital images shot on a Canon 10D

Category: Kew

Nothing is repeatable...
especially the light

BOB CROXFORD

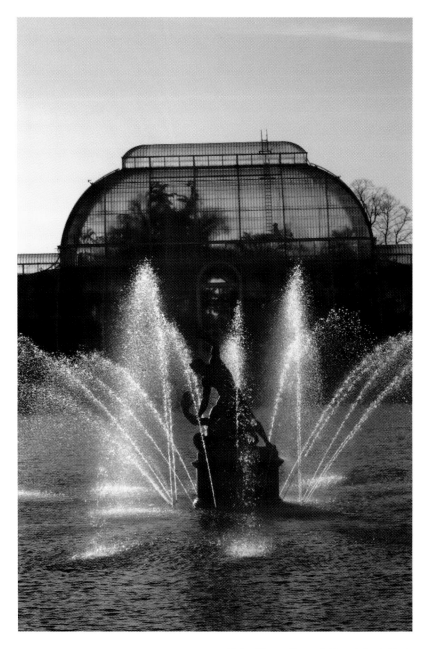

Palm House through Fountain at Dusk
Maddie Thornhill

Royal Botanic Gardens, Kew, UK
RAW Digital Image, at ISO 50,
on Canon EOS 1OD

Category: Views

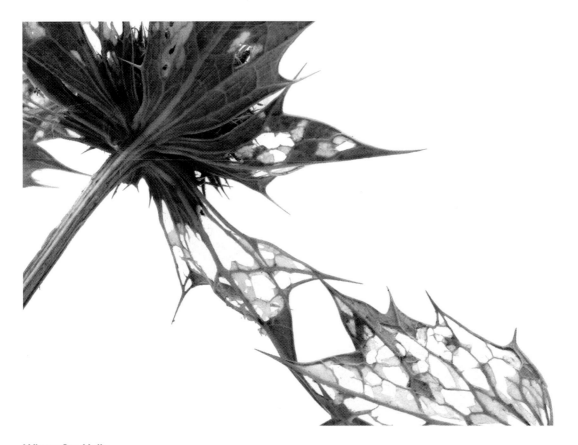

Winter Sea Holly
Philip Smith

Studio, Membury, Devon, UK
Digital shot on Nikon D100 (Studio lighting with daylight)

Category: Views

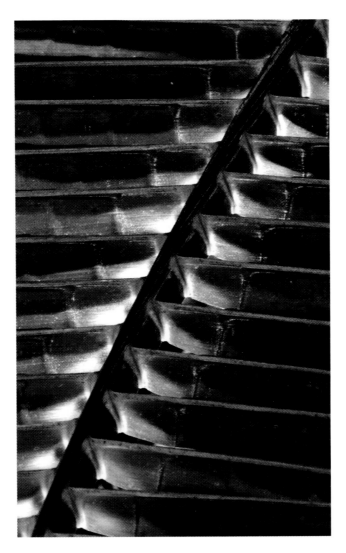

Palm in Palm House
Maddie Thornhill

Royal Botanic Gardens, Kew, UK
Digital shot on Canon EOS 1OD

Category: Kew

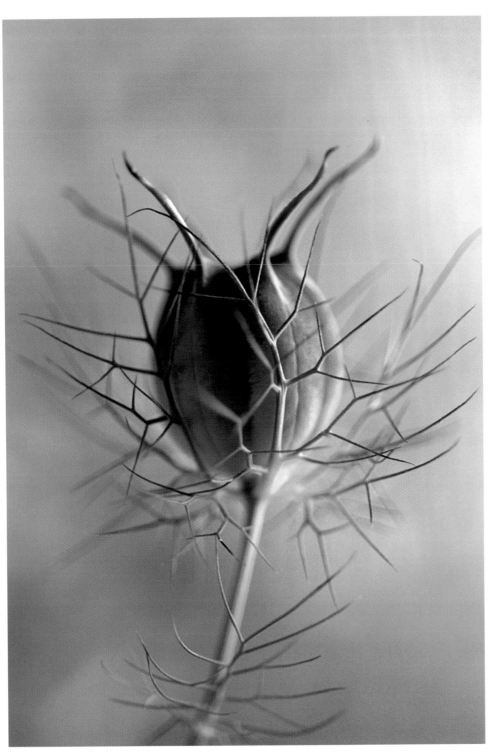

Newly formed *Nigella* Seedhead
Carol Sharp

Own Garden, Norfolk, UK
Colour transparency shot
on Nikon FM2

Category: New

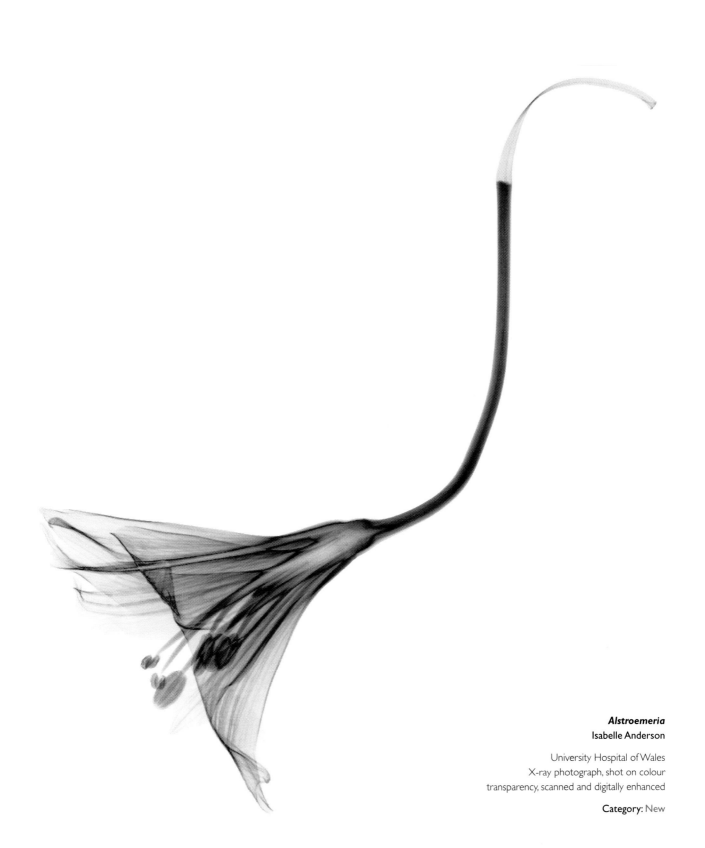

Alstroemeria
Isabelle Anderson

University Hospital of Wales
X-ray photograph, shot on colour
transparency, scanned and digitally enhanced

Category: New

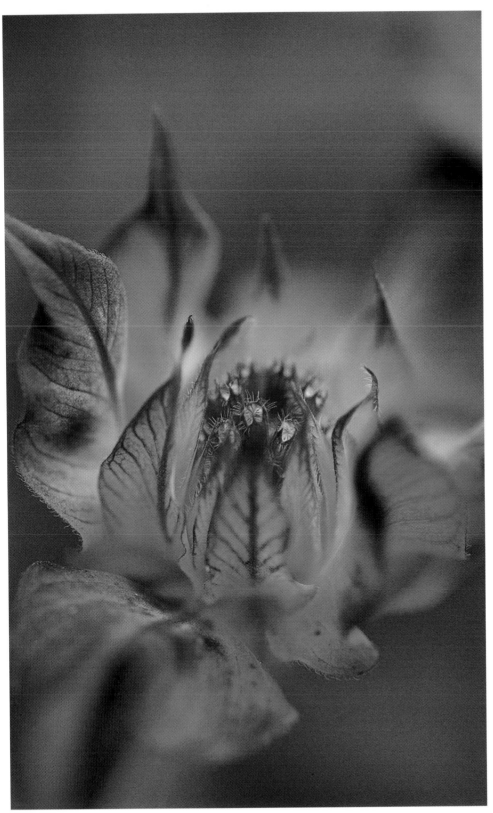

New *Monarda* 'Scorpion'
Dianna Jazwinski

RHS Gardens, Wisley, Surrey, UK
Colour transparency shot on
Canon EOS 600

Category: New

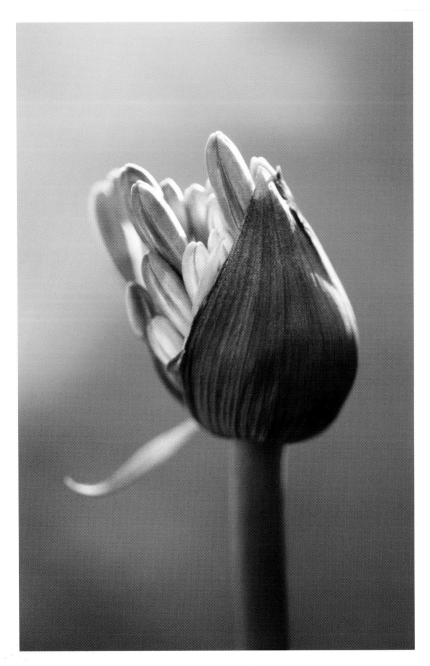

***Agapanthus* Emerging**
Carol Sharp

Norfolk, UK
Colour transparency shot on Nikon FM2

Category: New

6

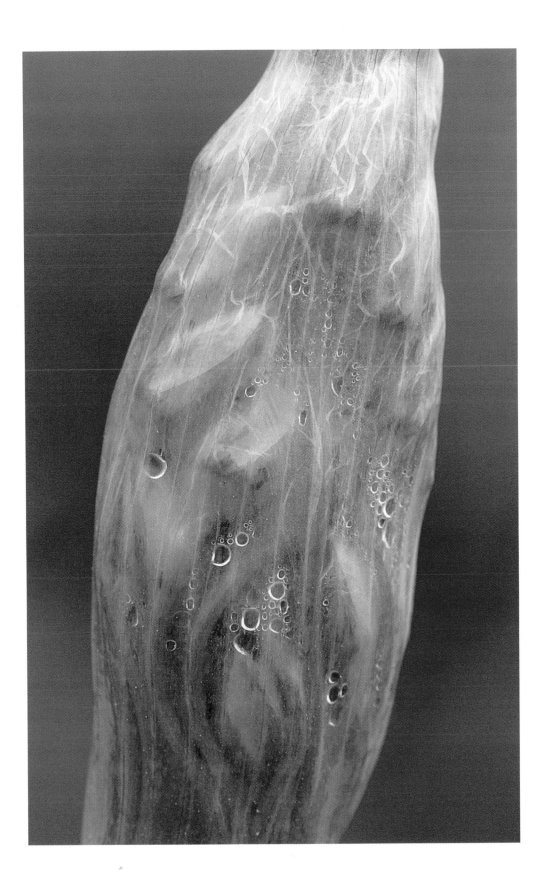

Judge's Favourite

Jess Walton
Creative Visual Research, London, UK

My eye was instantly drawn to the stunning image of *Nectaroscordum siculum* by Jonathan Buckley, which was quite a feat considering there were hundreds of photographs in the room. The image manages to be both simple and complex at the same time – it's a beautiful organic form with many layers to look through which give it extra depth. There is a kind of intimacy about the image that makes you feel you are the only one witnessing the birth of a new flower – you will be the first to see the fresh, vibrant tendrils of the flower as it emerges from its sheath. The longer you look the more you see…

At this level, photography isn't just about technical ability.
It's about 'seeing' what others may miss.

BEST OF SHOW
1 *Nectaroscordum siculum*
Jonathan Buckley

Beth Chatto Gardens, Essex, UK
Colour transparency shot on Nikon F100

Category: New
Judge's Favourite

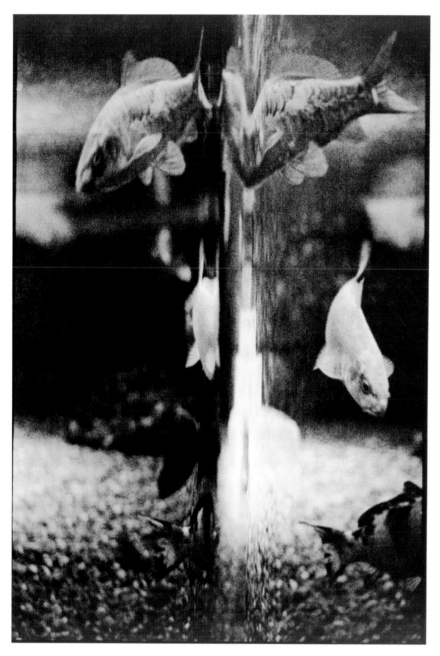

② Illusion
Victoria Upton

Royal Botanic Gardens, Kew, UK
Colour 5x4 transparency of black and white print

Category: Kew

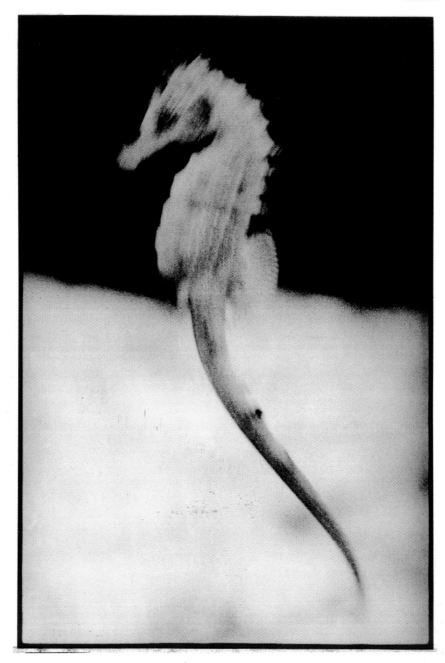

Seahorse at Kew Gardens
Victoria Upton

Royal Botanic Gardens, Kew, UK
Colour 5x4 transparency of black and white print

Category: Kew

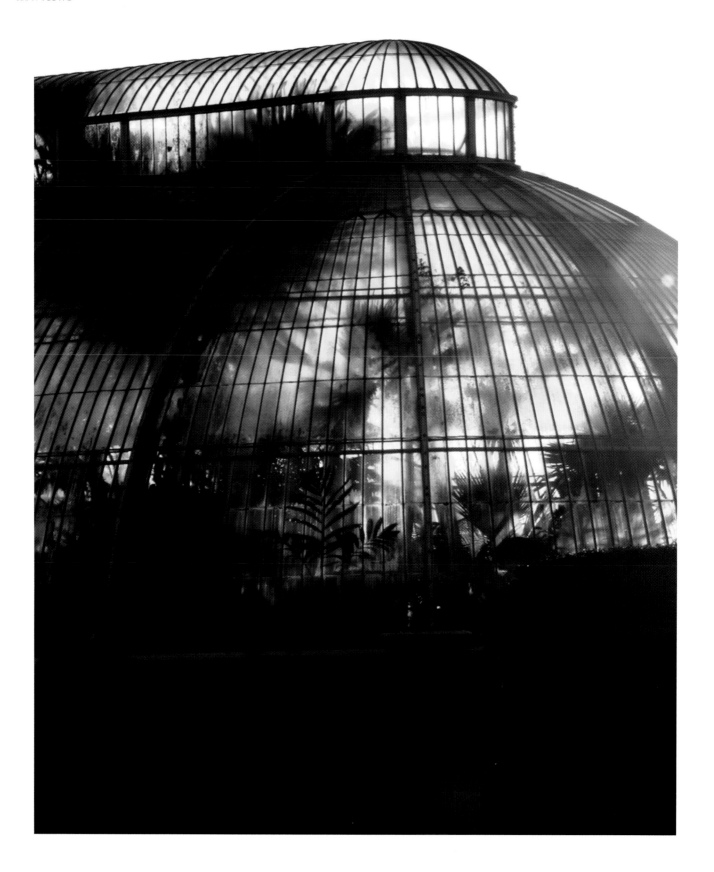

Palm House at Dusk
Maddie Thornhill

Royal Botanic Gardens, Kew, UK
Digital shot on Canon EOS 1OD

Category: Kew

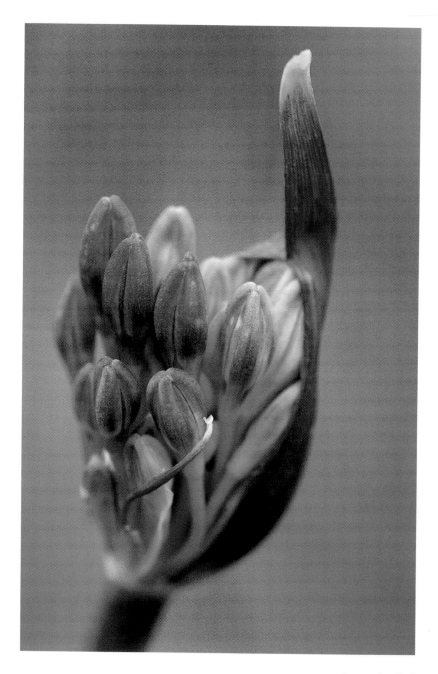

Agapanthus **Bud**
Rob Whitworth

1 Test Cottages, Hampshire, UK
Colour transparency shot on Nikon F100

Category: New

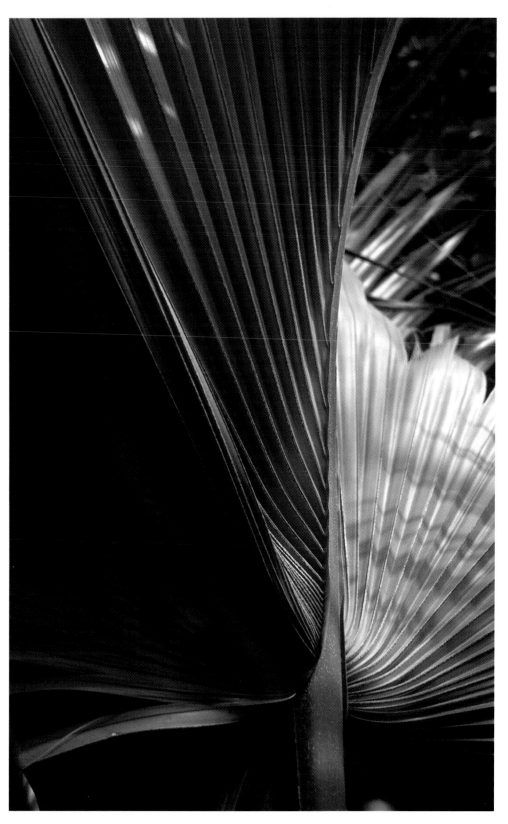

Palm House, Kew Gardens
Anthony Wallis

Royal Botanic Gardens, Kew, UK
Colour transparency on
Canon EOS5

Category: Kew

The question is not
what you look at
but what you see!

HENRY DAVID THOREAU

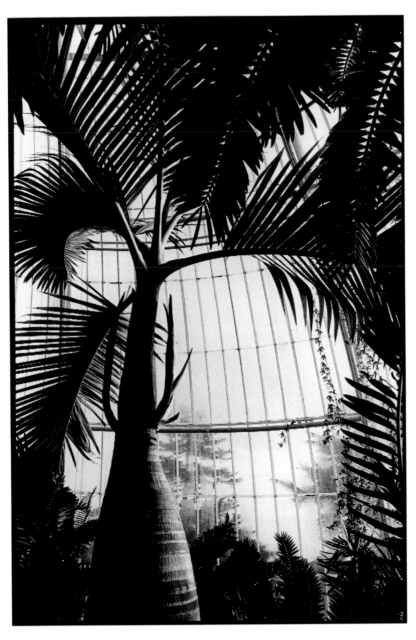

Inside Out
Peter Baistow

Royal Botanic Gardens, Kew, UK
Black and white negative shot on
Nikon 80

Category: Kew

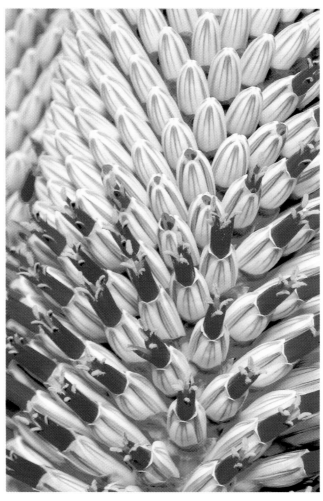

Aloe Flower Buds
Nadia Mackenzie

Royal Botanic Gardens, Kew, UK

Category: New

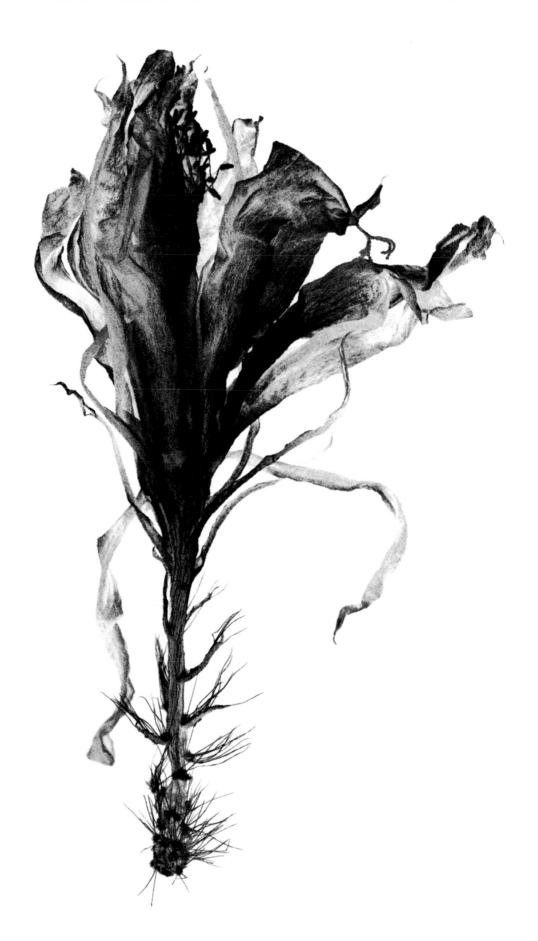

Kaktus No.1
Sanders Nicolson

Studio, London, UK
Colour negative shot on
Nikon

Category: Views

View of Garden in Dewdrops
Rosemary Calvert

Own Garden, Bramley, Surrey, UK
Colour transparency shot
on Canon EOS 10

Category: Views

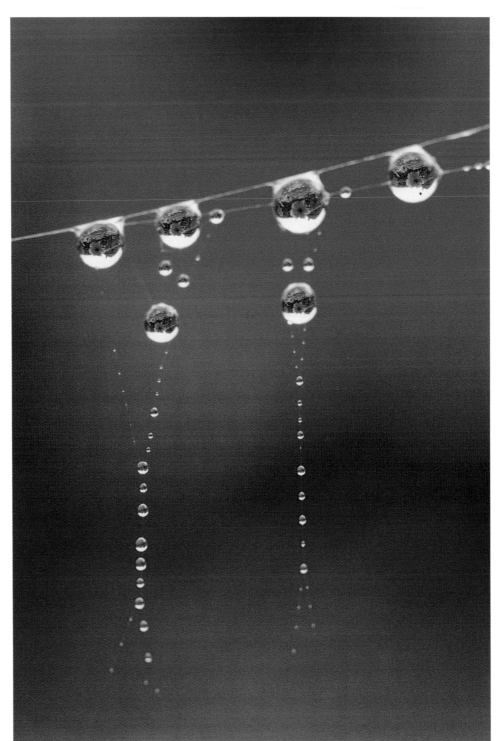

Judge's Favourite

Chris Young
Editor, Garden Design Journal, UK

Poppies, by their very nature, are beautiful, changing and exciting plants. However, in Richard Freestone's image, the intricate detail of such a plant is highlighted even more. The veining of the petals, the stem, and the graduation of colour, all contribute to make a beautiful plant even more sublime.

The way the image has been taken also adds to the air of detail and visual response. By taking the photograph from the underside of the flower, a different angle of view is created – making the detail more evident. Also, by giving it a white background, the colours and textures are dramatically increased.

To me, this images marries detail, atmosphere and quality in one stunning photograph.

Poppy
Richard Freestone

Derbyshire Garden, UK
Colour transparency
shot on Canon EOS1

Category: Views
Judge's Favourite

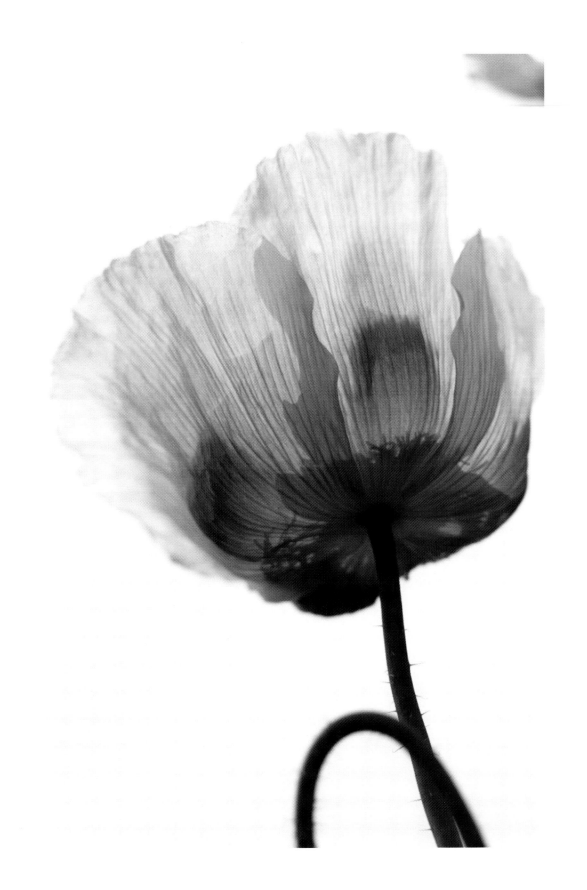

Honesty
Richard Freestone

Studio, UK
Scanogram – scanned on UMAX 110 Powerlook

Category: New

Seedheads
Jo Crowther

Quiberon Peninsula, Brittany. France
Colour negative shot on Nikon FM3A

Category: Views

02

A Spot of Nature
Sharon Elphick

Various locations including, Kew,
Wisley, Hyde Hall, local parks …, UK
Colour negative shot on Nikon F50

Category: New

04

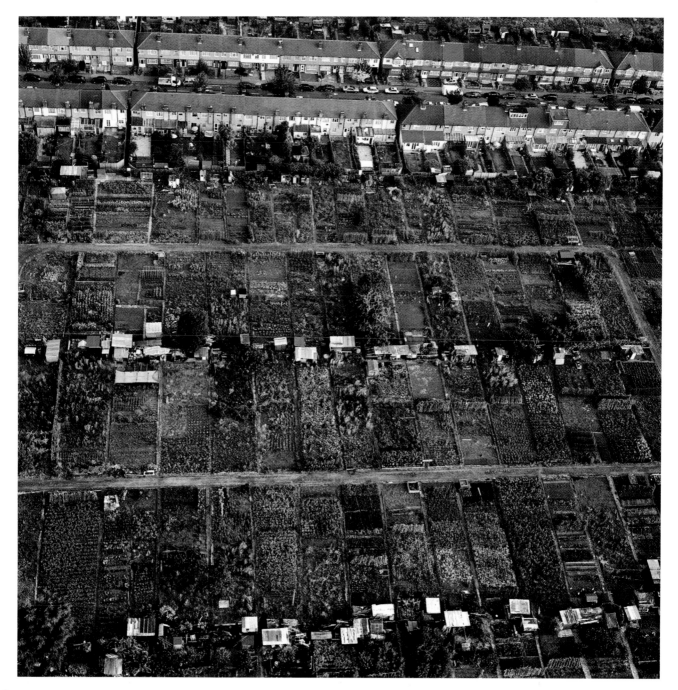

② **London Landscape: Allotments 6.30am**
Mimi Winter

South London, UK
Colour transparency shot on Hasselblad
500CM (Aerial shot from a balloon)

Category: Views

A Big Bamboo
Justyn Willsmore

Sir Harold Hillier Gardens, Ampfield,
nr. Romsey, Hampshire, UK
Colour transparency shot on Fuji GW 670III

Category: Views

Stormy Sky at Wakehurst Place
Derek Harris

Wakehurst Place, Sussex, UK
Colour transparency shot on Fuji 6x9

Category: Kew

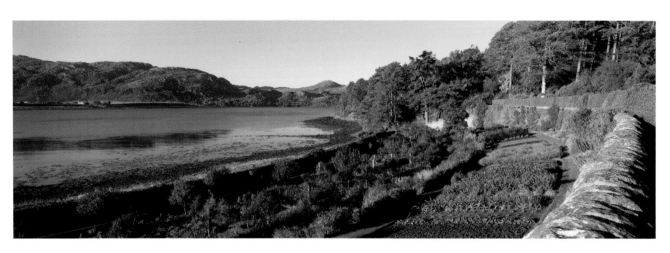

The Walled Garden
Andrea Jones

Inverewe Gardens, Inverewe, Scotland
Colour transparency shot on Fuji GX 617

Category: Views

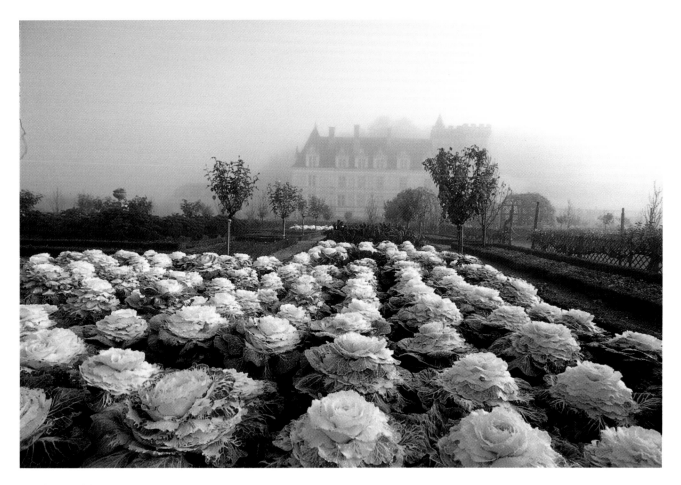

Coming into View
Michelle Garrett

Chateau Villandry, Loire, France
Colour transparency shot on Nikon FM3

Category: Views

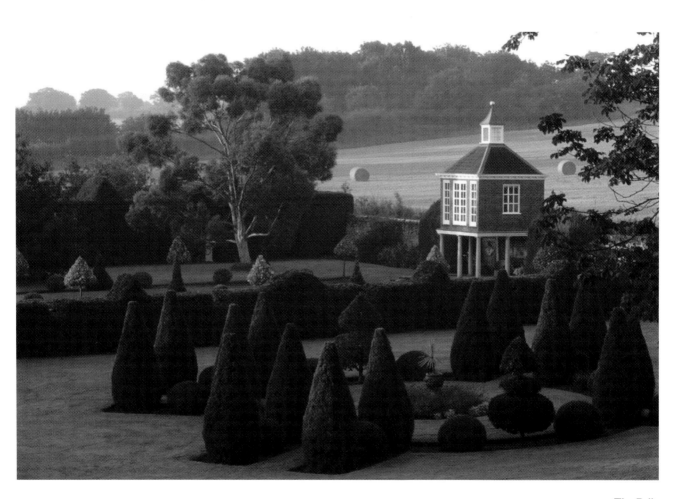

The Folly
Anne Green-Armytage

Hunworth Hall, Norfolk, UK
Colour transparency shot on Nikon 801s

Category: Views

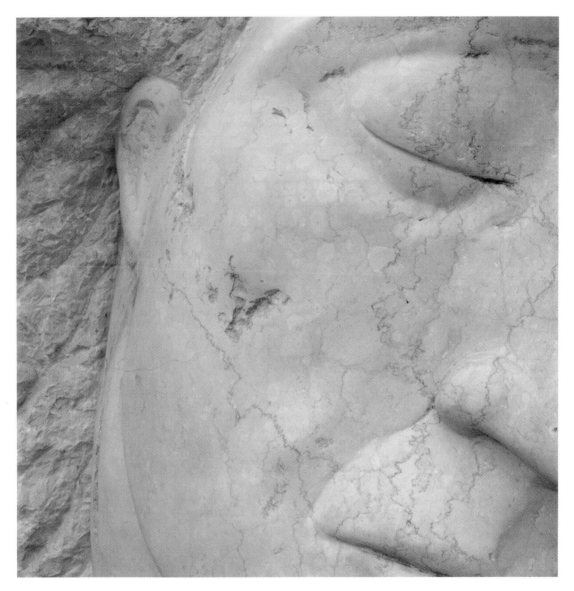

'Wounded Angel 1', sculpture by Emily Young 2003
Henrietta Van den Bergh

Royal Botanic Gardens, Kew, UK
Colour transparency shot on Hasselblad 501CM

Category: Kew

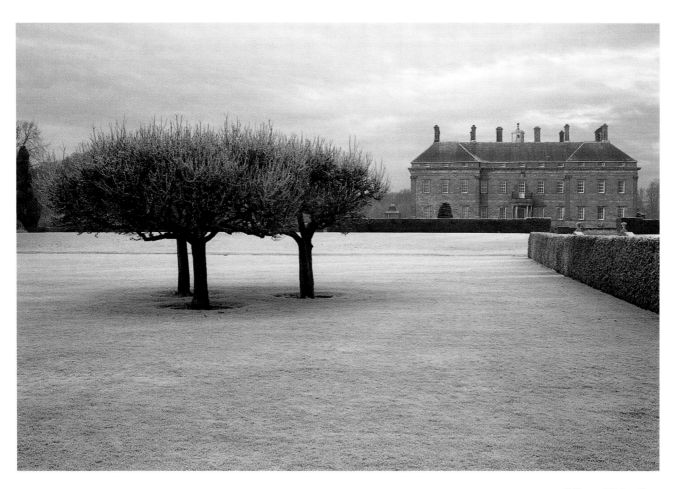

Winter Minimalism
Ray Cox

Kinross House, Kinross, Fife, Scotland, UK
Colour transparency shot on Canon EOS 5

Category: Views

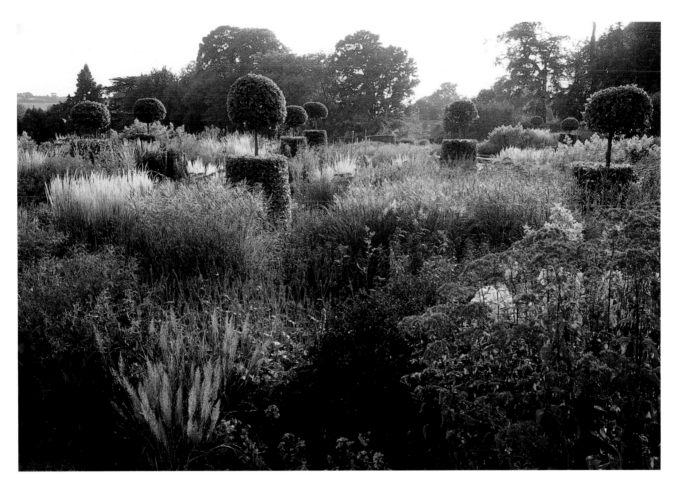

Private Garden, Oxfordshire.
Design and planting by Tom Stuart-Smith
Andrew Lawson

Oxfordshire, UK
Colour transparency shot on Canon F1

Category: Views

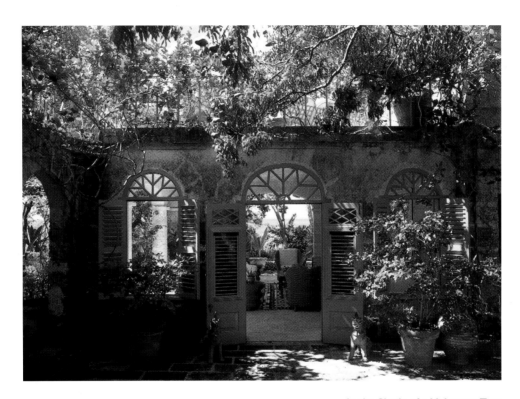

In the Shade of a Mahogany Tree
Derek St Romaine

Barbados
Colour transparency shot on Mamiya 645 Pro

Category: Views

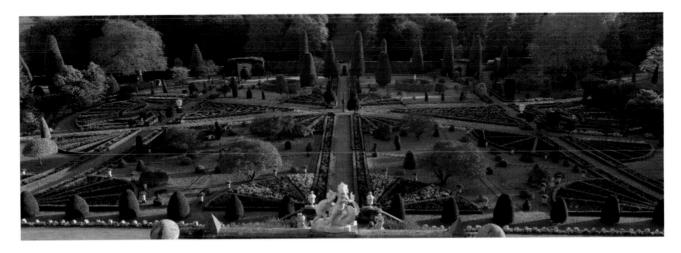

Garden
Kathy Collins

Drummond Gardens, Crieff, Perthshire, Scotland
Colour transparency shot on Fuji GX617

Category: Views

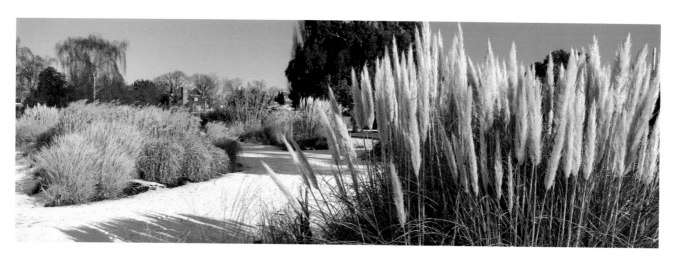

Winter in the Grasses Garden
Rob Whitworth

Royal Botanic Gardens, Kew, UK
Colour transparency shot on Hasselblad Xpan II

Category: Kew

...May had painted with her soft showers
A garden full of leaves and flowers.
And man's hand had arrayed it with such craft
There never was a garden of such price
But if it were the very Paradise.

GEOFFREY CHAUCER (1343–1400) **FROM** *THE CANTERBURY TALES*

Kew Spring I
Peter Baistow

Royal Botanic Gardens, Kew, UK
Black and white negative shot on
Nikon 80

Category: Views

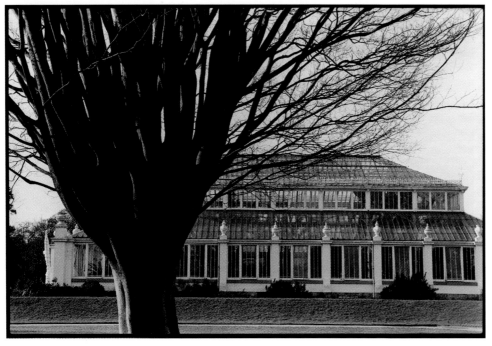

Kew Spring II
Peter Baistow

Royal Botanic Gardens, Kew, UK
Black and white negative shot on
Nikon 80

Category: Views

18

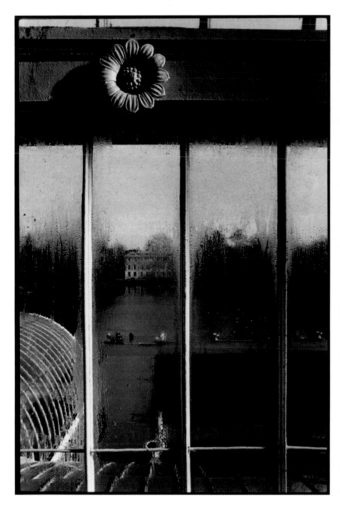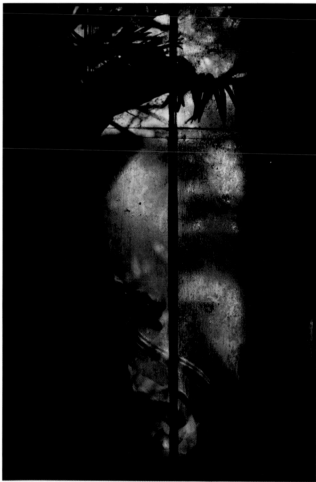

Inside Out (diptych)
Peter Baistow

Royal Botanic Gardens, Kew, UK
Black and white negative shot on Nikon 80

Category: Kew
Judge's Favourite

Judge's Favourite

Laura Giuffrida
Exhibition and Live Interpretations Manager,
Royal Botanic Gardens, Kew, Surrey, UK

I responded to the left-hand photograph of this diptych as soon as I saw it. Throughout the selection process we viewed hundreds of images, but this was the one that remained with me until the end of that long day. At first I thought that my reaction was largely emotional (a photograph of the building where I work, shot from the balcony of the Palm House, probably the most beautiful glasshouse in the world), but as I looked closer, I saw the strength and subtlety of the composition. I loved the use of black and white film, and the fact that Peter had chosen to photograph the Kew icon from the interior rather than the tempting exterior. The resulting image is taut, and understated. We are drawn through the casually wiped condensation on the glass, over the texture of the formal bedding below, and across the Pond to Museum No.1 – another Decimus Burton building. The view is timeless.

Despite the large number of superb photographs in the exhibition, I regularly return to this image. It still touches me.

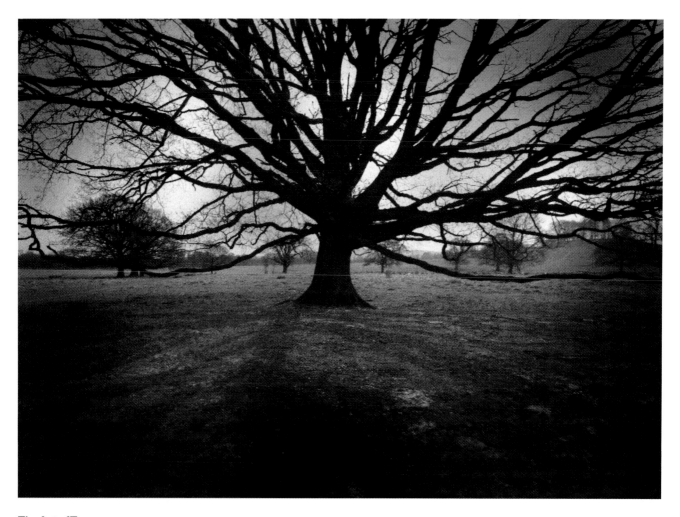

The Art of Trees
Steve Bicknell

UK
Digital shot on Canon EOS IDS

Category: Views

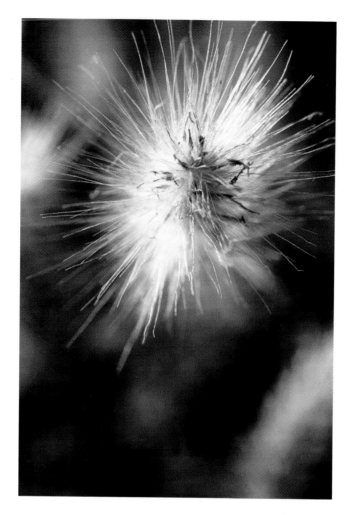

Pennisetum
Liz Eddison

Beaconsfield, UK
Colour transparency shot on
Nikon FM3A, digitally manipulated

Category: New

3 **Palm House (inside outside)**
Andrew Lawson

Royal Botanic Gardens, Kew, UK
Black and white negative film,
shot on Canon F1

Category: Kew

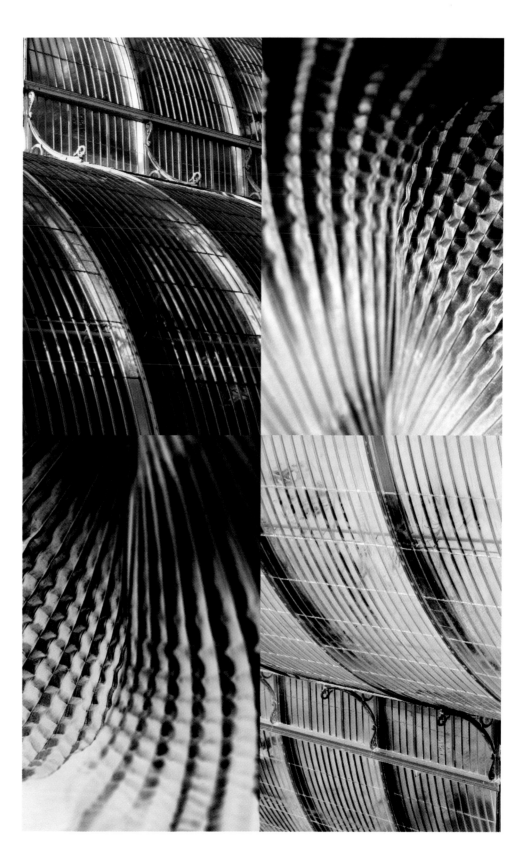

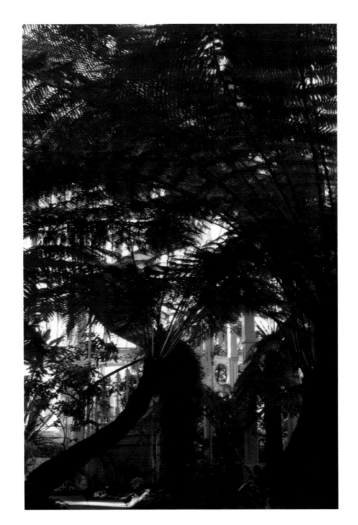

Tree Fern – Temperate House, Kew
Maddie Thornhill

Royal Botanic Gardens, Kew, UK
Digital shot on Canon EOS 10D

Category: Kew

Palm House at Night
Andrew McRobb

Royal Botanic Gardens, Kew, UK
Colour transparency shot on 6x17

Category: Kew

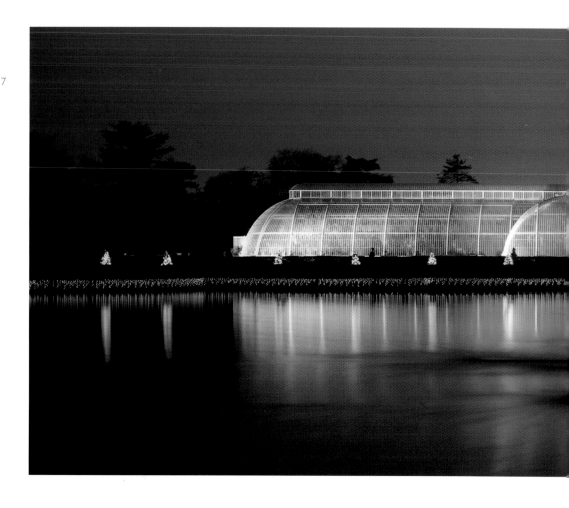

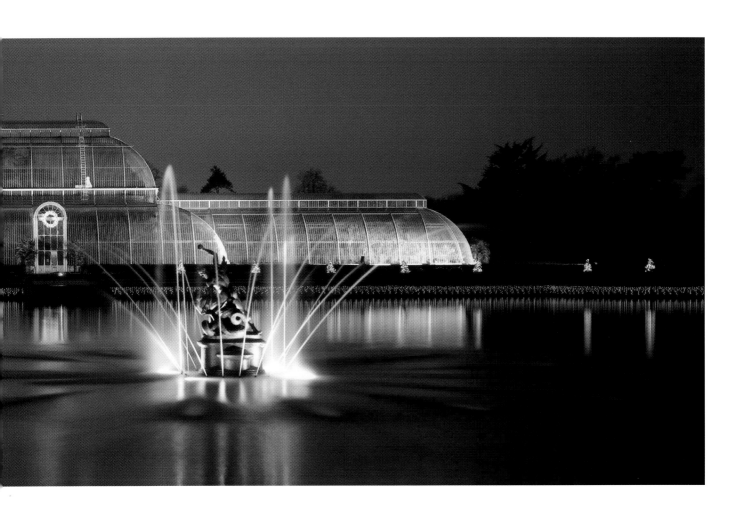

index of photographers

47, 83
Isabelle Anderson
13 Morris Finter Close
Ely
Cardiff
CF5 5BH
UK
T: +44 (0)29 2031 0999

94, 117, 118
Peter Baistow
4 Rusthall Place
Tunbridge Wells
Kent
TN4 8XB
UK
M: +44 (0)7796 492132
T: +44 (0)1895 525207
dbaistow@tiscali.co.uk

71
Susan Bell
55 Whitmore Gardens
London
NW10 5HE
UK
M: +44 (0)7966 243022
T: +44 (0)20 8968 8901
susanbell.photos@virgin.net

120
Steve Bicknell
Ashley House
Swan Corner
Pulborough
W Sussex
RH20 1AH
UK
T: +44 (0)1798 874464
F: +44 (0)1798 874484
steve@stevebicknell.co.uk
www.icarus-arts.com

24
Mark Bolton
24 Bellevue Crescent
Bristol
BS8 4TE
UK
T: +44 (0)117 926 0867
F: +44 (0)117 926 0867
mark@markbolton.co.uk
www.markbolton.co.uk

18, 36, 42, 44, 73, 86
Jonathan Buckley
Laurel Cottage
Queens Square
Chalford Hill
Stroud
Gloucestershire
GL6 8EG
UK
T: +44 (0)1453 889106
F: +44 (0)1453 889195
jonathan@jonathanbuckley.com

97
Rosemary Calvert
April Cottage
Birtley Rise
Bramley
Surrey
GU5 0HZ
UK
M: +44 (0)771 131 7040
T: +44 (0)1483 898415
F: +44 (0)1483 898415
rosemarycalvert@
rosemarycalvert.com
www.rosemarycalvert.com

114
Kathy Collins
Old Mill of Ross
Comrie
Perthshire
PH6 2JS
UK
T: +44 (0)1764 679884
KM.Collins@virgin.net
www.KathyCollins.co.uk

111
Ray Cox
Pitlowie House
Glencarse
Perth
Perthshire
PH2 7NS
UK
M: +44 (0)7762 067255
T: +44 (0)1738 860773
ray@rcoxgardenphotos.co.uk
www.rcoxgardenphotos.co.uk

66, 101
Jo Crowther
39a Leighton Grove
London
NW5 2QP
UK
M: +44 (0)7778 358131
T: +44 (0)20 7284 0060
F: +44 (0)20 7284 1303
matthead88@hotmail.com
www.jocrowther.com

60
Mike Curry
23 Greenwich Academy
50 Blackheath Road
Greenwich
London
SE10 8DZ
UK
T: +44 (0)7989 327272
F: +44 (0)7967 003267
mike@thephotographer.me.uk
www.thephotographer.me.uk

22, 67
Estelle Cuthbert
112b Thornlaw Road
West Norwood
London
SE27 0SB
UK
M: +44 (0)7855 275160
T: +44 (0)20 8670 2854
stellec@yahoo.co.uk

32
Francoise Davis
GardenWorld Images
Grange Studio
Woodham Road
Wickford
Essex
SS11 7QU
UK
T: +44 (0)1245 325725
F: +44 (0)1245 429198
info@gardenworldimages.com
www.gardenworldimages.com

26, 46, 63, 77
Paul Debois
14 Birch Grove
West Acton
London
W3 9SN
UK
M: +44 (0)7836 343380
T: +44 (0)20 8752 1973
paul@pauldebois.com
www.pauldebois.com

30, 121
Liz Eddison
6 Dorset Road
Harrow
Middlesex
HA1 4JG
UK
M: +44 (0)7973 602136
T: +44 (0)20 8863 8236
F: +44 (0)20 8863 6383
liz@lizeddison.com
www.lizeddison.com

103
Sharon Elphick
Studio W5
Cockpit Workshops
Northington Street
London
WC1N 2NP
UK
T: +44 (0)20 7813 3632
F: +44 (0)20 7813 3632
sharonelphick@yahoo.co.uk

29, 37, 39, 40, 65
Helen Fickling
14 Stratford Grove
Putney
London
SW15 1NU
UK
M: +44 (0)7976 946536
T: +44 (0)20 8785 2941
F: +44 (0)20 8788 1211
helen@helenfickling.com
www.helenfickling.com

74
Rachel Fish
Flat 2
56 Fairfield Road
Winchester
SO22 6SG
UK
M: +44 (0)7739 224050
T: +44 (0)1962 629411
F: +44 (0)1962 629411
rachelfish@ntlworld.com
www.rachelfish.co.uk

99, 100
Richard Freestone
The Studio
Crownyard
Wirksworth
Derbyshire
DE4 4ET
UK
M: +44 (0)7968 889258
T: +44 (0)1629 824862
rdf@dircon.co.uk
www.richardfreestone.com

59, 108
Michelle Garrett
28 Edith Road
London
W14 9BB
UK
M: +44 (0)7949 377290
T: +44 (0)20 7603 8759
F: +44 (0)20 7603 8510
michelle.garrett@ukonline.co.uk
www.garden-photographers.com/gpg

76
Steve Gosling
The Red House
16 St Winifreds Road
Harrogate
North Yorkshire
HG2 8LN
UK
M: +44 (0)7769 967933
T: +44 (0)1423 881987
steve.gosling@virgin.net
www.stevegoslingphotography.co.uk

34, 69, 109
Anne Green-Armytage
Quince Farm
Spring Lane
Yaxham
Dereham
Norfolk
NR19 1SA
UK
T: +44 (0)1362 694223
F: +44 (0)1362 854035
anne@annegreenarmytage.com
www.annegreenarmytage.com

45
Johnny Greig
46 Ramsden Road
London
SW12 8QY
UK
M: +44 (0)7774 134405
T: +44 (0)20 8772 1259
F: +44 (0)20 8772 1259
johnny@johnnygreig.com
www.johnnygreig.com

27
Marcus Harpur
44 Roxwell Road
Chelmsford
Essex
CM1 2NB
UK
T: +44 (0)1245 257527
F: +44 (0)1245 344101
harpur.garden.library@dsl.pipex.com
www.harpurgardenlibrary.com

106
Derek Harris
Woodland Publishing
Holmleigh Farm
Huntsgate
Gedney Broadgate
Spalding
Lincolnshire
PE12 0DG
UK
T: +44 (0)1406 366503
F: +44 (0)1406 366502
derekharris.associates@virgin.net

50
Mark Harwood
12 The Waterside
44–48 Wharf Road
London
N1 7SF
UK
M: +44 (0)7702 233721
T: +44 (0)20 7490 8787
F: +44 (0)20 7490 1009
mail@markharwood.plus.com
www.markharwoodstudio.co.uk

68
Charlie Hopkinson
2 Choumert Mews
London
SE15 4BD
UK
M: +44 (0)7976 402 891
T: +44 (0)20 7277 7659
F: +44 (0)20 7277 7659
hoppo@charliehopkinson.com
www.charliehopkinson.com

20
Caroline Hughes
30 Torridon Road
Hither Green
London
SE6 1AQ
UK
M: +44 (0)7973 481043
T: +44 (0)20 8698 6176
carolinehughes@onetel.net.uk

84
Dianna Jazwinski
9 Merrion Court
55 Bournemouth Road
Poole
Dorset
BH14 0EN
UK
T: +44 (0)1202 723511
dijaz@jazwinski.freeserve.co.uk

21, 61, 107
Andrea Jones
316 Kew Road
Kew gardens
TW9 3DU
UK
M: +44 (0)7798 504555
T: +44 (0)20 8287 0600
F: +44 (0)20 8287 0606
pictures@gardenexposures.co.uk
www.gardenexposures.co.uk

23, 38, 112, 122
Andrew Lawson
Noah's Ark
Market Street
Charlbury
Oxford
OX7 3PL
UK
T: +44 (0)1608 810654
F: +44 (0)1608 811251
photos@andrewlawson.com
www.andrewlawson.com

54
Tara Lee
29 Inverness Terrace
London
W2 3JR
Uk
M: +44 (0)7976 350692
taralees2000@aol.com
www.taraleephoto.com

64
Richard Loader
Furzehill Farm
South Gorley
Fording Bridge
Hants
SP6 2PT
UK
T: +44 (0)1425 653361
F: +44 (0)1202 843821
photomacro@aol.com

53, 55, 62
Derek Lomas
45 Ingate Place
Battersea
London
SW8 3NS
UK
M: +44 (0)7956 561799
T: +44 (0)20 7622 0123
F: +44 (0)20 7720 8357
derek.lomas@btopenworld.com
www.dereklomas.com

70, 95
Nadia Mackenzie
43 Palmerston Road
London
SW14 7QA
UK
M: +44 (0)7831 284473
F: +44 (0)20 8255 9152
nadia@nadiamackenzie.com

124
Andrew McRobb
c/o Sir Joseph Banks Building
Royal Botanic Gardens
Kew, Surrey
TW3 3AB
UK
T: +44 (0)20 8332 5760
F: +44 (0)20 8332 5646
A.Mcrobb@rgbkew.org.uk

17, 28, 33
Clive Nichols
Rickyard Barn
Castle Farm
Chacombe
Banbury
Oxon
OX17 2EN
UK
M: +44 (0)7802 354833
T: +44 (0)1295 712288
F: +44 (0)1295 713672
enquiries@clivenichols.com
www.clivenichols.com

31, 35
Trevor Nicholson Christie
2 Weeton Terrace
Weeton
N.Yorks
LS17 0BB
UK
M: +44 (0)7973 366937
T: +44 (0)1423 734424
F: +44 (0)113 343 3252
trevor@tncphotography.co.uk
www.tncphotography.co.uk

49, 96
Sanders Nicolson
Charity House
14/15 Perseverance Works
38 Kingsland Road
London
E2 8DD
UK
T: +44 (0)20 7739 6987
F: +44 (0)20 7729 4056
mail@sandersnicolson.com
www.sandersnicolson.com

52
Gary Rogers
Hofweg 9
22085 Hamburg
Germany
M: +49 172 429 5030
T: +49 40 229 8674
F: +49 40 229 8674
garyRfoto@aol.com
www.garyrogers-foto.com

56
Jane Sebire
13 Egerton Road South
Stockport
UK
T: +44 (0)161 282 5788
F: +44 (0)161 282 5788
janesebire@yahoo.co.uk

43, 82, 85
Carol Sharp
71 Leonard Street
London
EC2A 4QU
UK
M: +44 (0)7802 183723
T: +44 (0)20 7729 8040
F: +44 (0)20 7729 7909
carol@carolsharp.co.uk
www.carolsharp.co.uk

19
Andy Small
Well Cottage
Farleigh Road
Cliddesden
Hants
RG25 2JD
UK
M: +44 (0)7944 521367
T: +44 (0)1256 322600
F: +44 (0)1256 322600
andy@andysmall.com

80
Philip Smith
Rock Farm
Memsbury
Axminster
Devon
EX13 7AG
UK
T: +44 (0)1404 881718
F: +44 (0)1404 881718
info@digitalbarn.co.uk

113
Derek St Romaine
239a Hook Road
Chessington
KT9 1EQ
UK
T: +44 (0)20 8397 3761
F: +44 (0)20 8397 3960
derek@gardenphotolibrary.com
www.gardenphotolibrary.com

51
Tomoko Suzuki
Agent: Tiffany Radmore
Visual Arts
1st Floor
9 Prescot Street
London
E1 8PR
UK
M: +44 (0)7480 4654
eastandwest@mbi.nifty.com

79, 81, 90, 123
Maddie Thornhill
74 Marine Parade
Worthing
W Sussex
BN11 3QB
UK
M: +44 (0)7973 757156
T: +44 (0)1903 237971
F: +44 (0)1903 237971
maddiethornhill@btinternet.com

48, 88, 89
Victoria Upton
27 Chippenham Mews
London
W9 2AN
UK
M: +44 (0)7976 358919
T: +44 (0)20 82664255
www.victoriauptonphotography.com

110
Henrietta Van den Bergh
Church House
Broadway
Ilminster
Somerset
TA19 9RB
UK
M: +44 (0)7973 838452
T: +44 (0)1460 54365
F: +44 (0)1460 54365
info@hvdbphoto.com
www.hvdbphoto.com

92
Anthony Wallis
21 Wrentham Avenue
London
NW10 3HS
UK
T: +44 (0)20 8960 1549
twallis1@btinternet.com
www.tonywallisphotos.co.uk

25, 72
Jo Whitworth
1 Test Cottages
St Mary Bourne
Andover
Hants
SP11 6BX
UK
T: +44 (0)1264 738074
F: +44 (0)1264 738074
jo.whitworth@virgin.net

75, 91, 115
Rob Whitworth
1 Test Cottages
St Mary Bourne
Andover
Hants
SP11 6BX
UK
T: +44 (0)1264 738074
F: +44 (0)1264 738074
rob.whitworth@virgin.net

105
Justyn Willsmore
The Coach House
1 Bassett Row
Southampton
Hampshire
SO16 7FT
UK
T: +44 (0)23 8076 8651
F: +44 (0)23 8076 8651
justyn@theimagebiz.com
www.theimagebiz.com

104
Mimi Winter
Flat D
13 Northbourne Road
London
SW4 7DW
UK
T: +44 (0)7968 120148
F: +44 (0)20 7622 6250
mimiwinterpictures@yahoo.com